EWE DO EWE

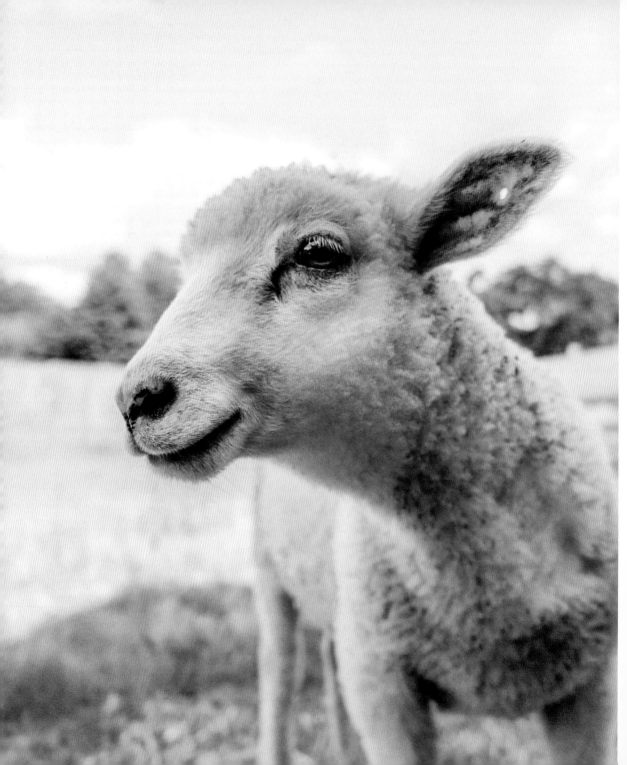

EWE DO EWE

WISDOM TO GET YOU
THROUGH THE GOOD, THE BAAAD,
AND EVERYTHING IN BETWEEN

APOLLO
PUBLISHERS

Contents

1

PUTTING YOUR BEST HOOF FORWARD

I don't like to gamble, but if there's one thing I'm willing to bet on, it's myself.

———

BEYONCÉ

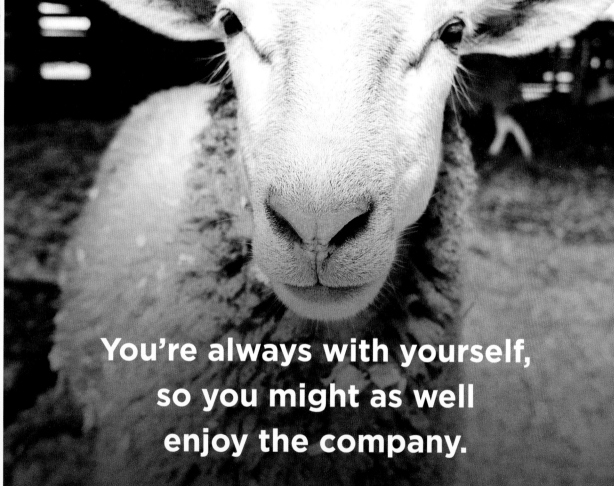

You're always with yourself, so you might as well enjoy the company.

DIANE VON FURSTENBERG

Happiness is not a goal . . . it's a by-product of a life well lived.

ELEANOR ROOSEVELT

It is impossible to live without failing at something, unless you live so cautiously that you might as well not have lived at all, in which case you have failed by default.

———

J. K. ROWLING

Beauty begins the moment you decide to be yourself.

——————

COCO CHANEL

The fool doth think
he is wise, but the
wise man knows
himself to be a fool.

WILLIAM SHAKESPEARE

Inaction breeds doubt and fear. Action breeds confidence and courage. If you want to conquer fear, do not sit home and think about it. Go out and get busy.

DALE CARNEGIE

We're all golden sunflowers inside.

ALLEN GINSBERG

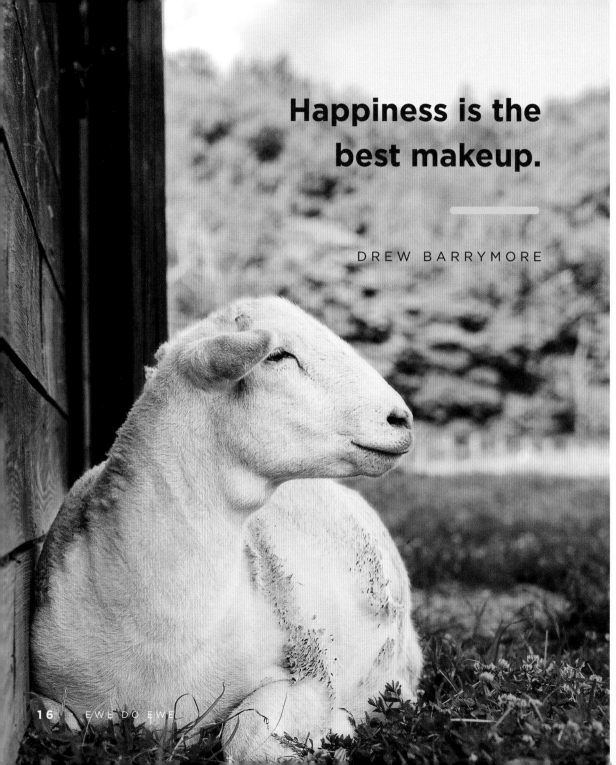

Happiness is the
best makeup.

DREW BARRYMORE

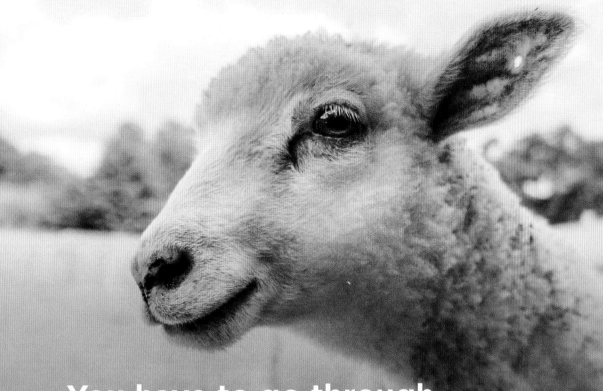

You have to go through the falling down in order to learn to walk.

———

CAROL BURNETT

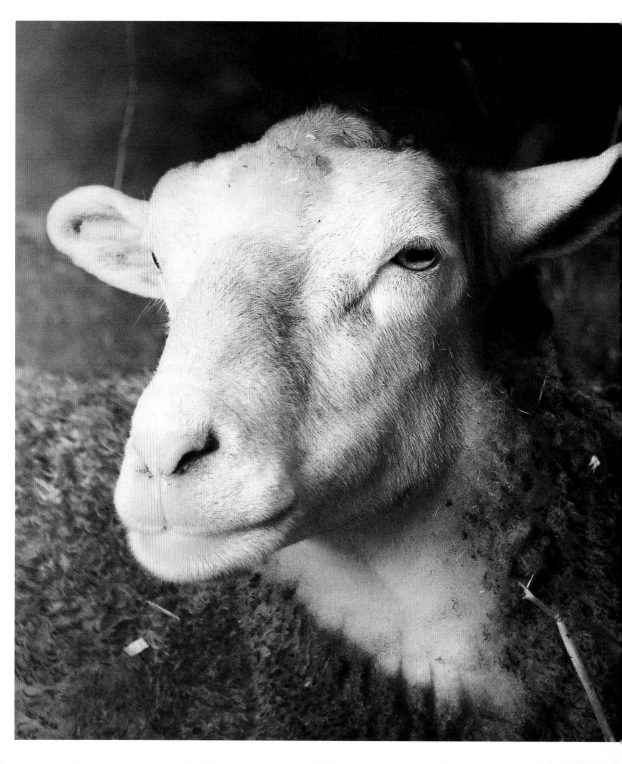

I really don't think I need buns of steel. I'd be happy with buns of cinnamon.

ELLEN DEGENERES

Rule number one is, don't sweat the small stuff. Rule number two is, it's all small stuff.

ROBERT ELIOT

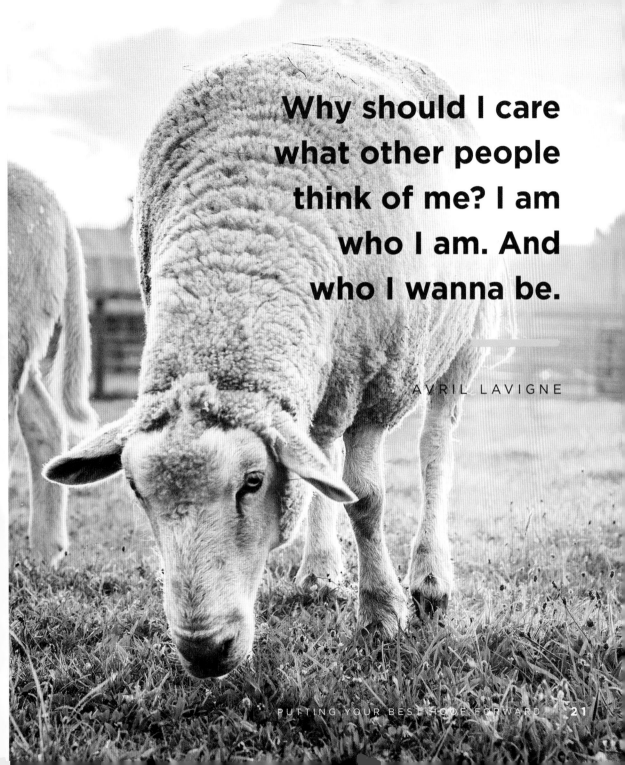

Why should I care what other people think of me? I am who I am. And who I wanna be.

AVRIL LAVIGNE

Don't ask yourself what the world needs. Ask yourself what makes you come alive, and go do that, because what the world needs is people who have come alive.

HOWARD THURMAN

If you invite negativity in, you have to feed it and hang out with it. Best not to invite it in.

ERYKAH BADU

If you don't know what you want, you end up with a lot you don't.

———

CHUCK PALAHNIUK

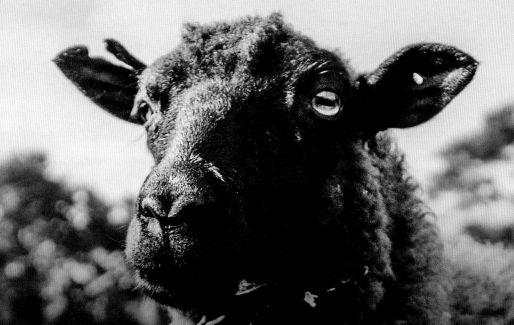

You don't need directions, just point yourself to the top and go!

———

DWAYNE JOHNSON

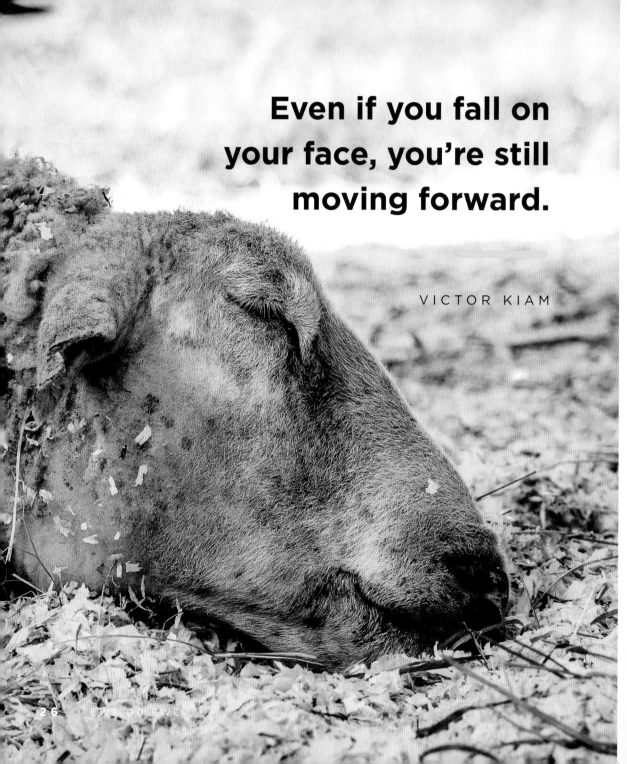

Even if you fall on your face, you're still moving forward.

VICTOR KIAM

In three words, I can sum up everything I've learned about life. It goes on.

—————

ROBERT FROST

It is good to have an end to journey toward; but it is the journey that matters, in the end.

URSULA K. LE GUIN

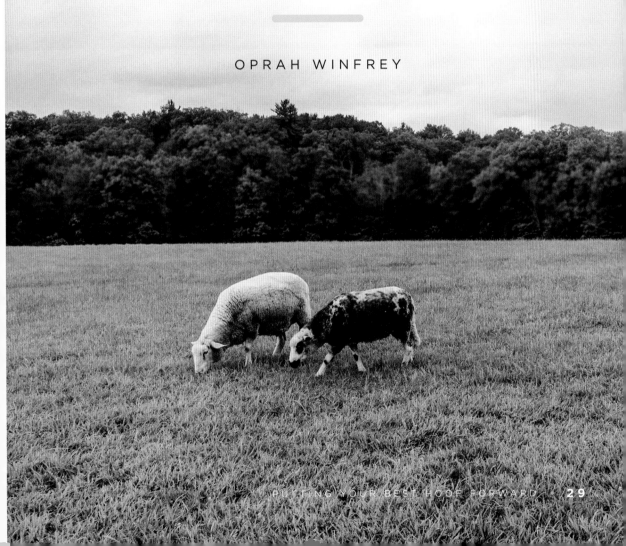

You are not your circumstances. You are your possibilities. If you know that, you can do anything.

OPRAH WINFREY

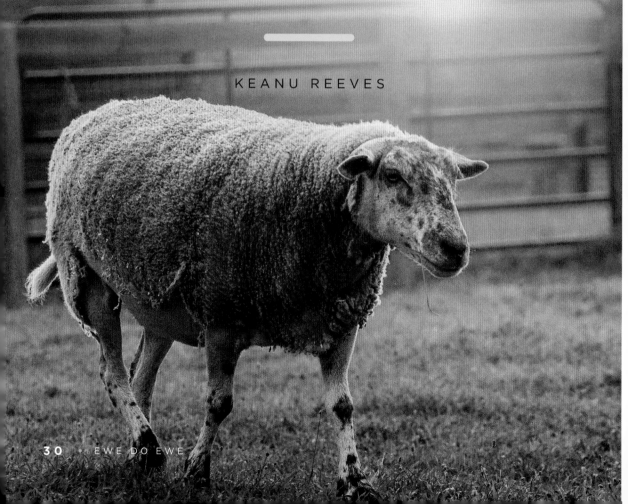

The best way to change is to make mistakes. You can learn from your mistakes and then you keep moving on.

KEANU REEVES

When you're confronted with life you can either be cowardly or you can be brave, but either way you're going to live. So you might as well be brave.

RAPHAEL BOB-WAKSBERG

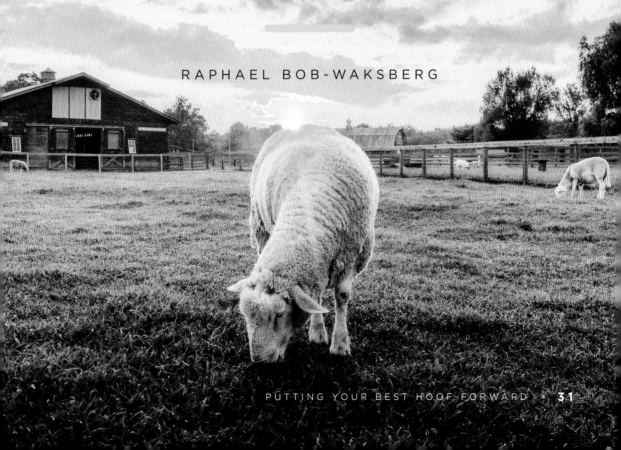

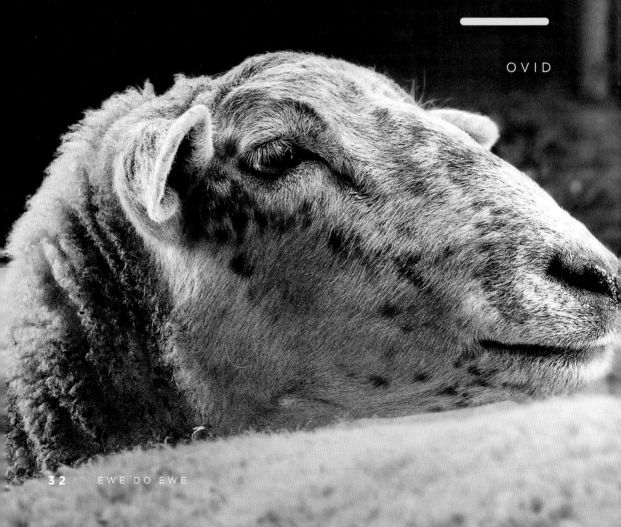

Let others praise
ancient times; I am glad
I was born in these.

—

OVID

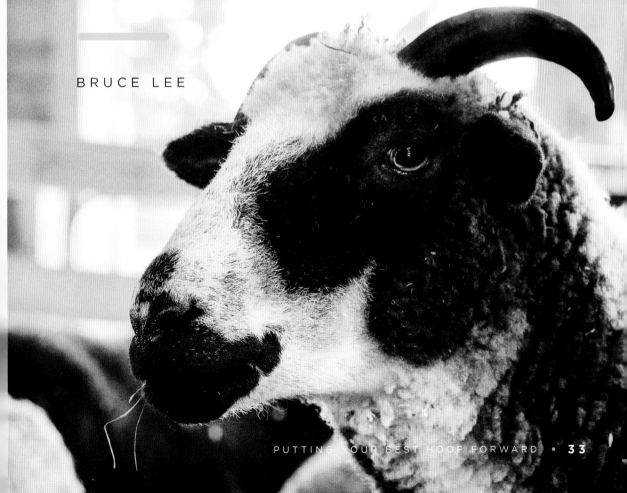

A goal is not always meant to be reached, it often serves simply as something to aim at.

BRUCE LEE

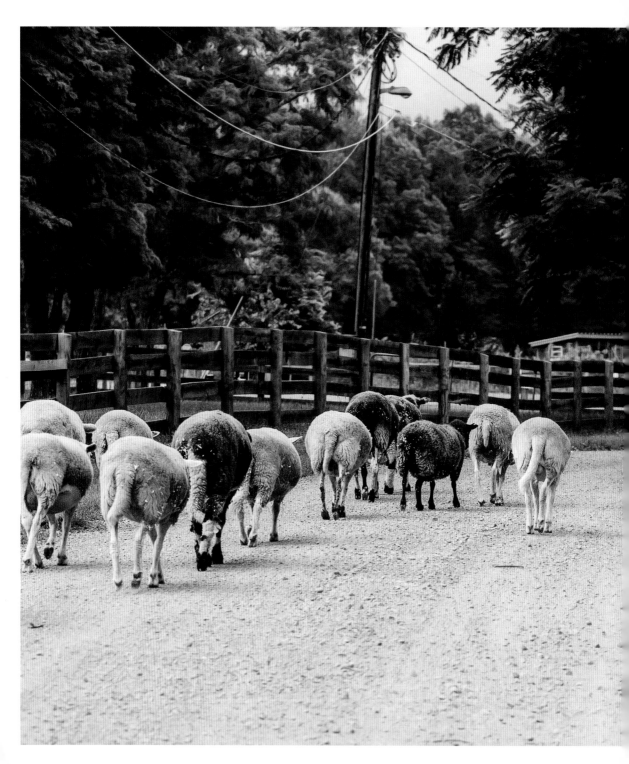

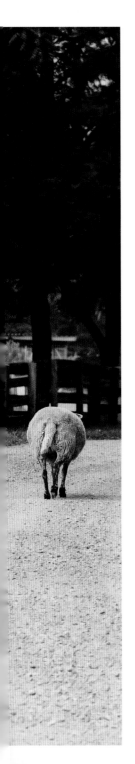

If you don't know where you are going, any road will get you there.

———

LEWIS CARROLL

You just have to keep trying to do good work, and hope that it leads to more good work. I want to look back on my career and be proud of the work, and be proud that I tried everything. Yes, I want to look back and know that I was terrible at a variety of things.

——————

JON STEWART

Why do you go away? So that you can come back. So that you can see the place you came from with new eyes and extra colors. And the people there see you differently, too. Coming back to where you started is not the same as never leaving.

———

TERRY PRATCHETT

The old days were the old days. And they were great days. But now is now.

DON RICKLES

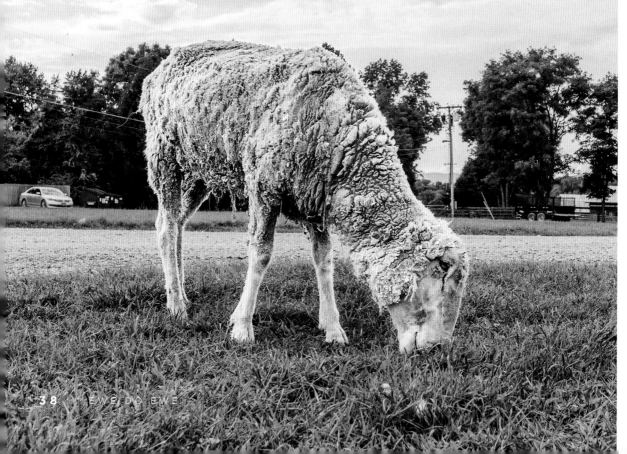

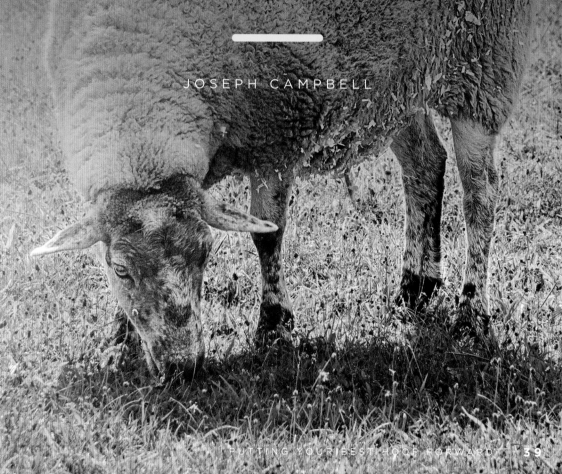

I don't believe people are looking for the meaning of life as much as they are looking for the experience of being alive.

JOSEPH CAMPBELL

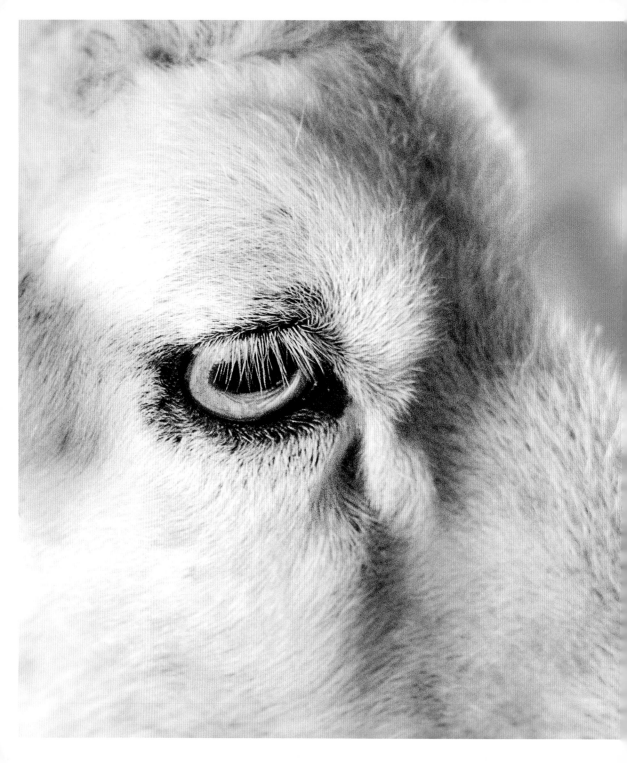

Don't let yesterday take up too much of today.

WILL ROGERS

2

STANDING OUT FROM THE FLOCK

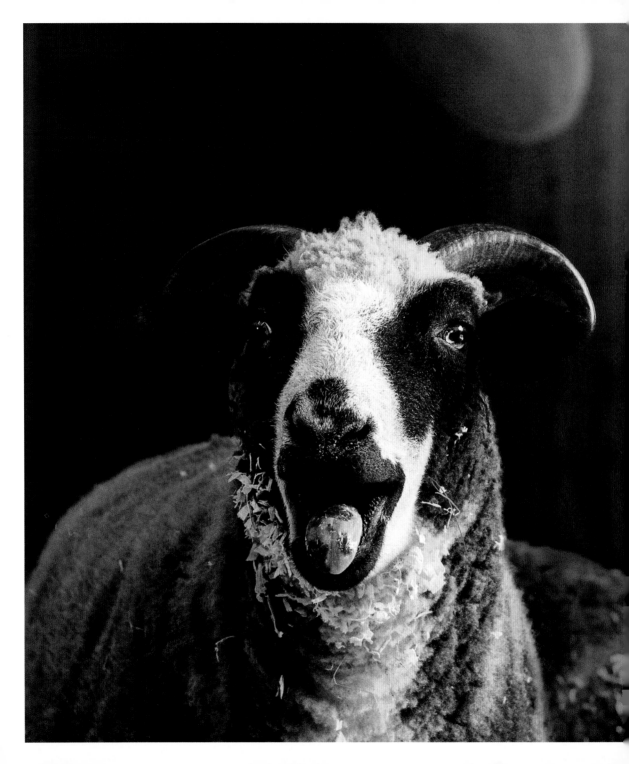

Everything weird about you is beautiful and makes life interesting.

———

KESHA

I would always rather be happy than dignified.

———

CHARLOTTE BRONTË

Wonder shows in the light of our eyes. Without it, they become dull and old.

———

GOLDIE HAWN

I like to eat meals
I will remember.
Otherwise, what's
the point?

———

NANCY MEYERS

You can't imagine what satisfaction can be gotten from throwing a pie into someone's face.

EMMA THOMPSON

The chief enemy of creativity is "good" sense.

PABLO PICASSO

When life gives you lemons don't make lemonade, make pink lemonade. Be unique.

———

WANDA SYKES

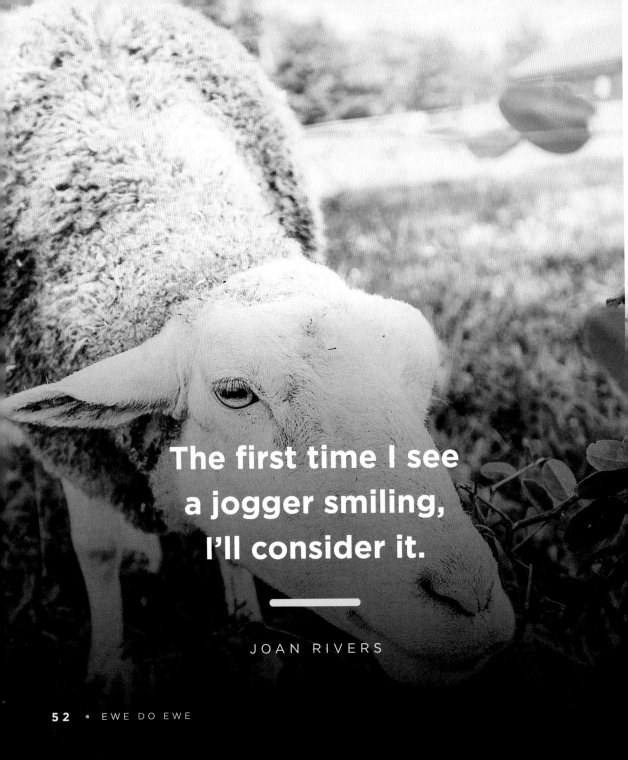

The first time I see
a jogger smiling,
I'll consider it.

JOAN RIVERS

I think what makes people fascinating is conflict, it's drama, it's the human condition. Nobody wants to watch perfection.

———

NICOLAS CAGE

Creativity is allowing yourself to make mistakes. Art is knowing which ones to keep.

———

SCOTT ADAMS

Strength lies in differences, not in similarities.

———

STEPHEN COVEY

There are no rules. . . . That is how art is born, how breakthroughs happen. Go against the rules or ignore the rules. That is what invention is about.

—————

HELEN FRANKENTHALER

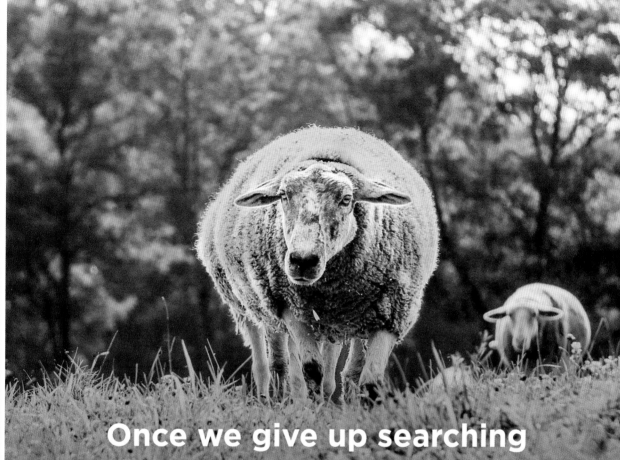

Once we give up searching for approval, we often find it easier to earn respect.

——

GLORIA STEINEM

Do not allow people to dim your shine because they are blinded. Tell them to put on some sunglasses, 'cause we were born this way.

LADY GAGA

To be yourself in a world that is constantly trying to make you something else is the greatest accomplishment.

RALPH WALDO EMERSON

My favorite time of day is to get up and eat leftovers from dinner, especially spicy food.

———

DAVID BYRNE

You put on eyeliner, and people start screaming at you. How strange, and how marvelous.

ROBERT SMITH

Originality—a target best hit when not aimed at.

CHARLES SEARLE

I was never aware of any other option but to question everything.

Know thyself? If I knew myself, I would run away.

———

JOHANN WOLFGANG VON GOETHE

Silly is you in a natural state,
and serious is something
you have to do until you
can get silly again.

——————

MIKE MYERS

We need the tonic of wildness.

———

HENRY DAVID THOREAU

You should bring something into the world that wasn't in the world before. It doesn't matter what that is. It doesn't matter if it's a table or a film or gardening—everyone should create. You should do something, then sit back and say, "I did that."

———

RICKY GERVAIS

Life is about doing the things that make you happy, not the things that please other people. If you can please other people, that's a plus, but as long as you're not hurting anyone, you're golden.

NICOLE RICHIE

I was wise enough never to grow up, while fooling people into believing I had.

———

MARGARET MEAD

In this world, being a little crazy helps to keep you sane.

———

ZSA ZSA GÁBOR

I always wanted to be somebody, but now I realize I should have been more specific.

LILY TOMLIN

Talent hits a target no one else can hit. Genius hits a target no one else can see.

————————

ARTHUR SCHOPENHAUER

Cherish forever what makes you unique, 'cause you're really a yawn if it goes.

BETTE MIDLER

I owe my success to having listened respectfully to the very best advice, and then going away and doing the exact opposite.

———

G. K. CHESTERTON

I don't like defining myself. I just am.

BRITNEY SPEARS

You have to know how to accept rejection and reject acceptance.

RAY BRADBURY

I don't know
why people
expect art to
make sense. They
accept the fact
that life doesn't
make sense.

DAVID LYNCH

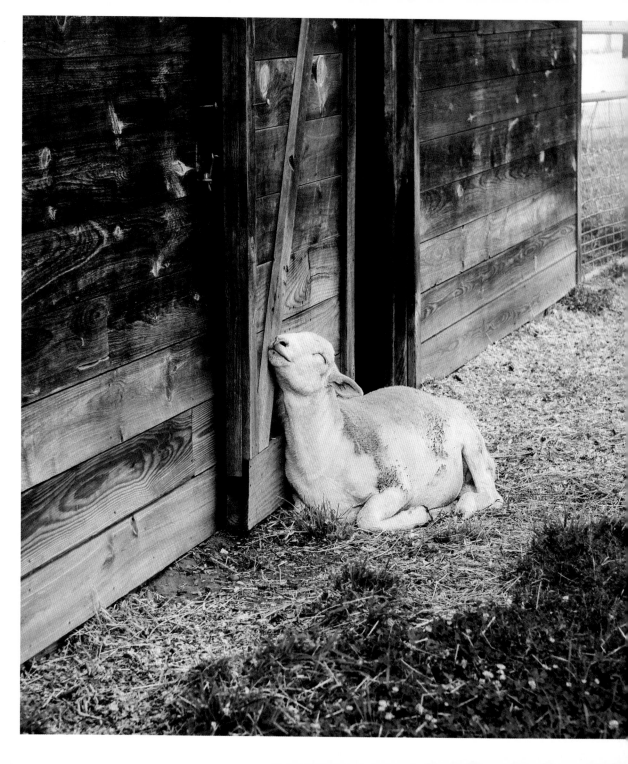

I have a lot of growing up to do. I realized that the other day inside my fort.

ZACH GALIFIANAKIS

3

I'LL BE THERE FOR EWE

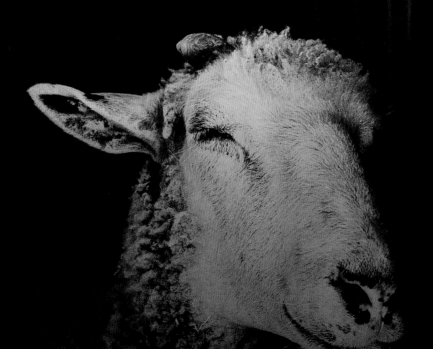

Be kind to unkind people.
They need it the most.

——————

ASHLEIGH BRILLIANT

Goodness is about character—integrity, honesty, kindness, generosity, moral courage, and the like. More than anything else, it is about how we treat other people.

———

DENNIS PRAGER

I have made a lot of mistakes falling in love, and regretted most of them, but never the potatoes that went with them.

NORA EPHRON

EWE DO EWE

True humility is not thinking less of yourself; it is thinking of yourself less.

C. S. LEWIS

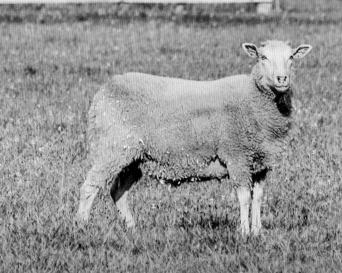

A lot of my fears and anxieties are the fears and anxieties of a six-year-old boy. When I finally confront them, they're really small.

—————

BILL BURR

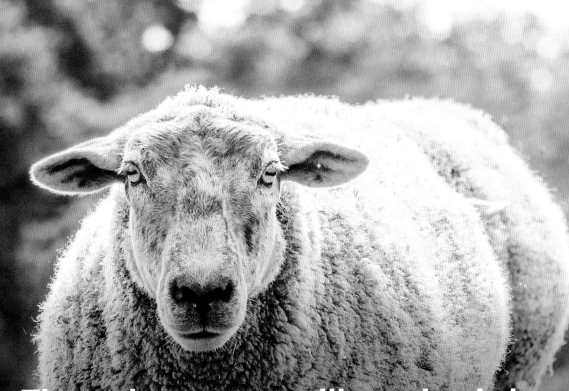

The only way we will survive is by being kind. The only way we can get by in this world is through the help we receive from others.

———

Even though
I am critical
or judgmental
of society at
large, I'm not
critical of people
individually. We
are who we are.

————

IAN MACKAYE

Kindness can only be repaid with kindness. It can't be repaid with expressions like "thank you" and then forgotten.

MALALA YOUSAFZAI

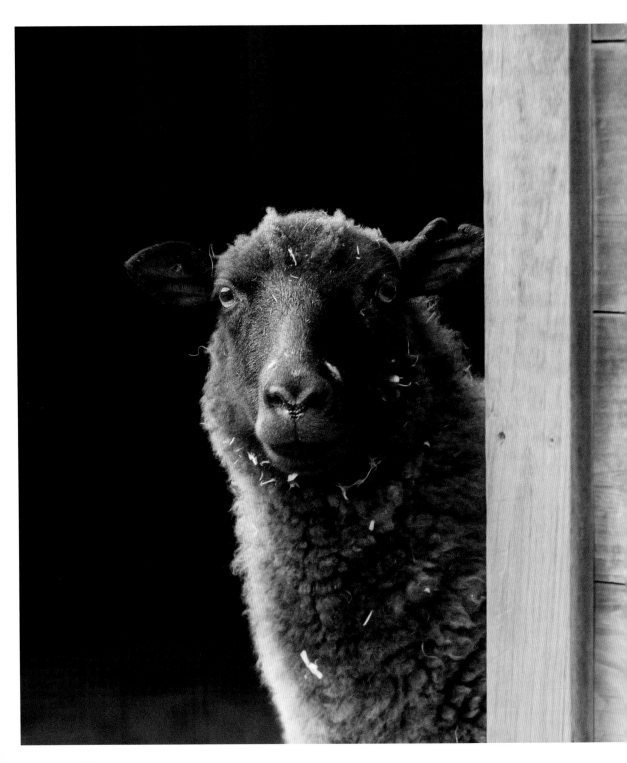

Happiness comes from being who you actually are instead of who you think you are supposed to be.

SHONDA RHIMES

Never let your sense
of morals prevent
you from doing
what is right.

———

ISAAC ASIMOV

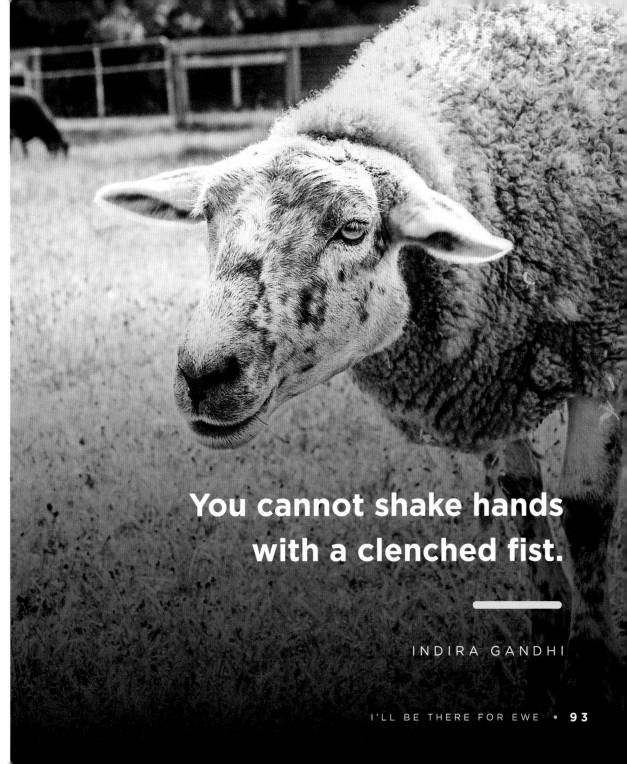

You cannot shake hands
with a clenched fist.

INDIRA GANDHI

Be kind whenever possible.
It is always possible.

DALAI LAMA

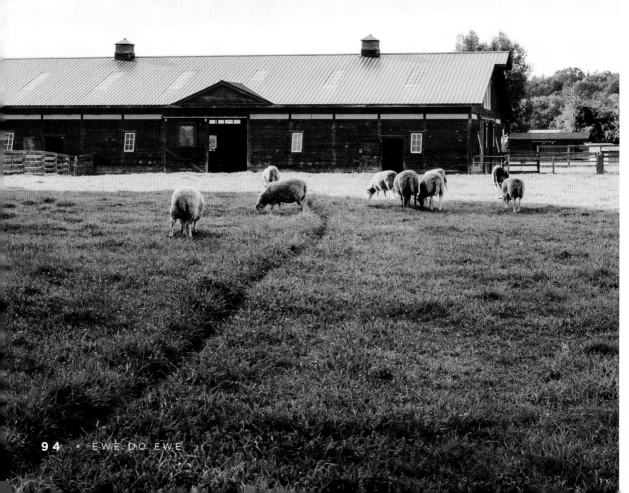

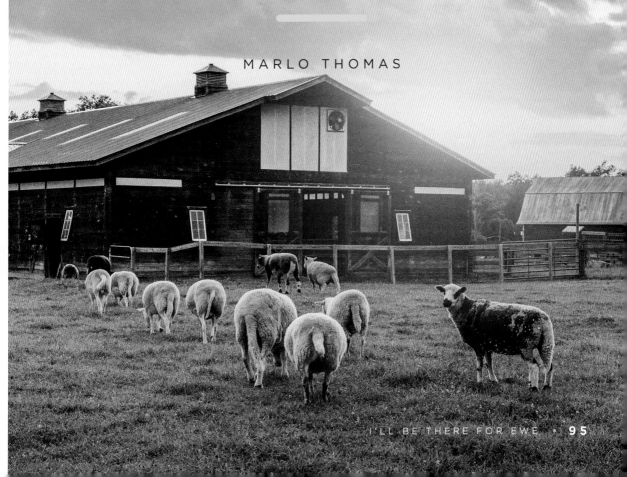

My father said there were two kinds of people in the world: givers and takers. The takers may eat better, but the givers sleep better.

MARLO THOMAS

He is no fool who gives
what he cannot keep to
gain what he cannot lose

———

JIM ELLIOT

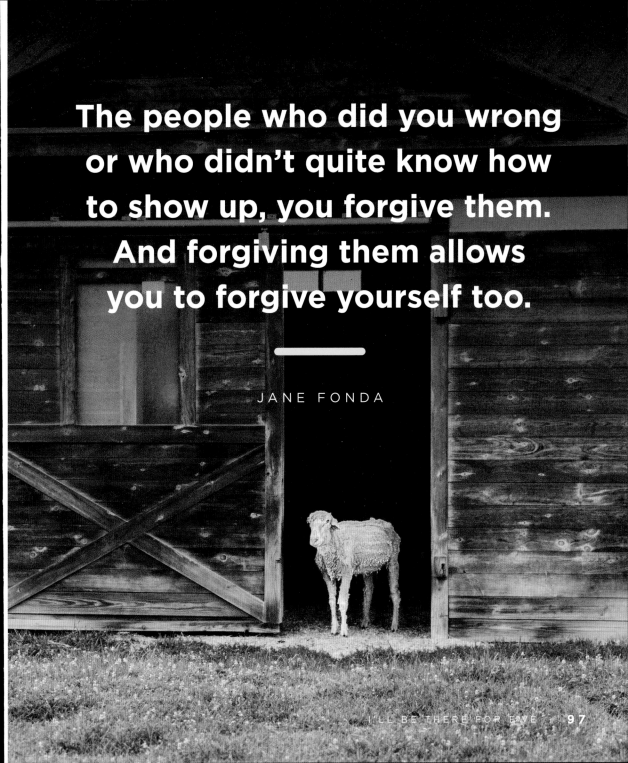

The people who did you wrong or who didn't quite know how to show up, you forgive them. And forgiving them allows you to forgive yourself too.

JANE FONDA

Perhaps all the dragons in our lives are princesses who are only waiting to see us act, just once, with beauty and courage. Perhaps everything that frightens us is, in its deepest essence, something helpless that wants our love.

———

RAINER MARIA RILKE

Ethics are more
important than laws.

———

WYNTON MARSALIS

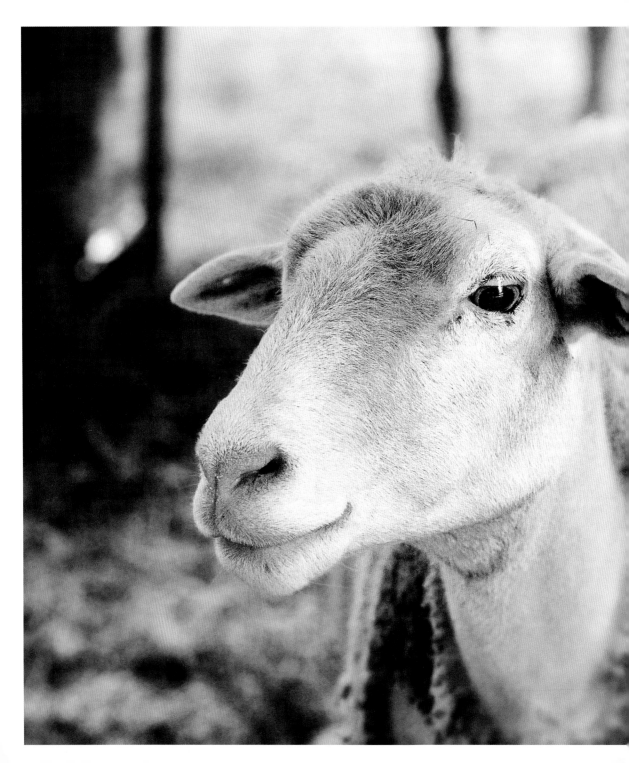

It is more fun to talk with someone who doesn't use long, difficult words but rather short, easy words like "What about lunch?"

———

A. A. MILNE,
WINNIE-THE-POOH

No matter what happens in life, be good to people. Being good to people is a wonderful legacy to leave behind.

——

TAYLOR SWIFT

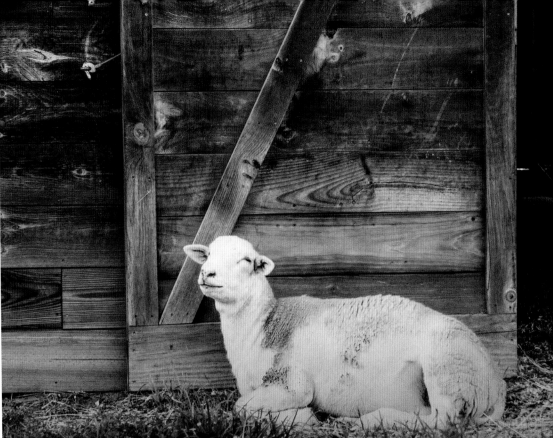

Live by the harmless untruths that make you brave and kind and healthy and happy.

KURT VONNEGUT

4

THE WORLD IS YOUR PASTURE

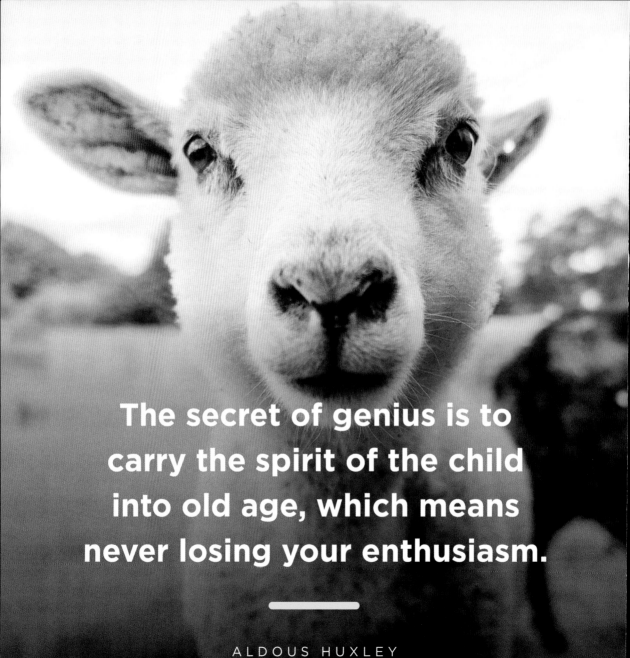

The secret of genius is to carry the spirit of the child into old age, which means never losing your enthusiasm.

ALDOUS HUXLEY

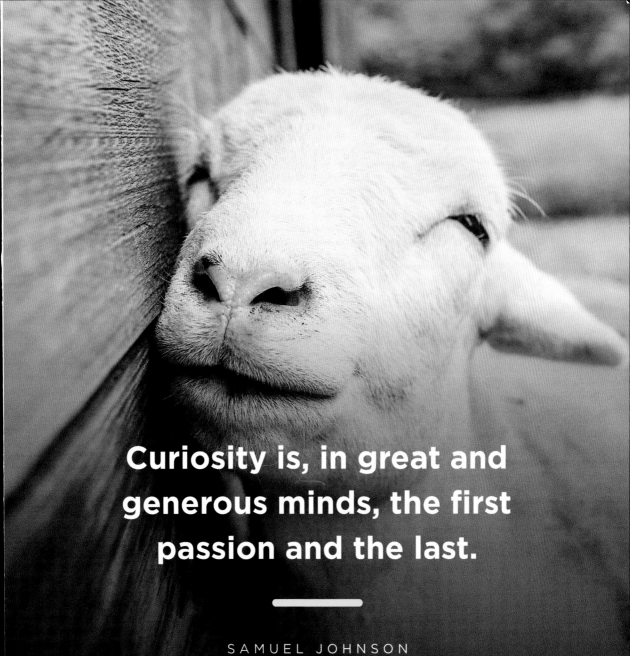

Curiosity is, in great and generous minds, the first passion and the last.

SAMUEL JOHNSON

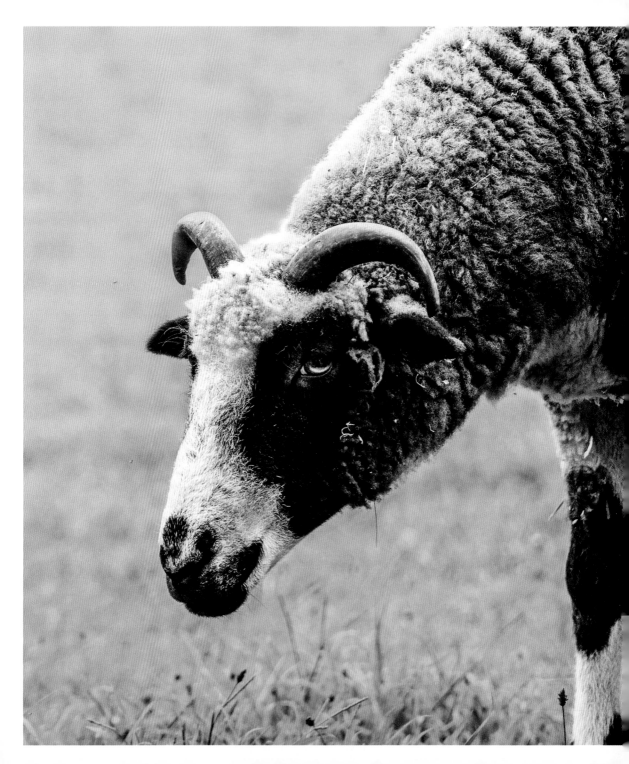

The only thing I want to do is stuff with people who care about what they're doing.

JOSEPH
GORDON-LEVITT

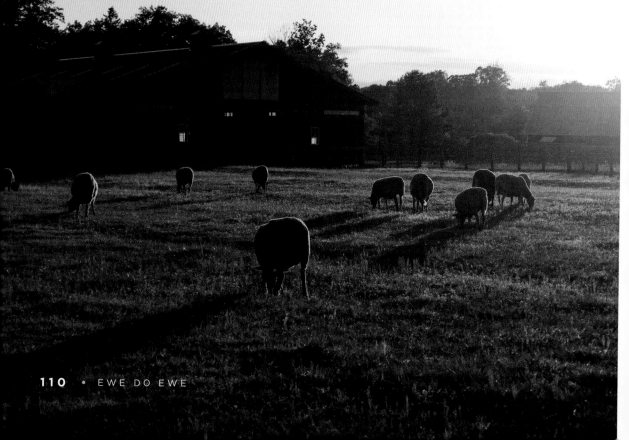

Retirement is not in my vocabulary. They aren't going to get rid of me that way.

BETTY WHITE

Everybody talks about wanting to change things and help and fix, but ultimately all you can do is fix yourself. And that's a lot. Because if you can fix yourself, it has a ripple effect.

ROB REINER

———

My optimism wears heavy boots and is loud.

—

HENRY ROLLINS

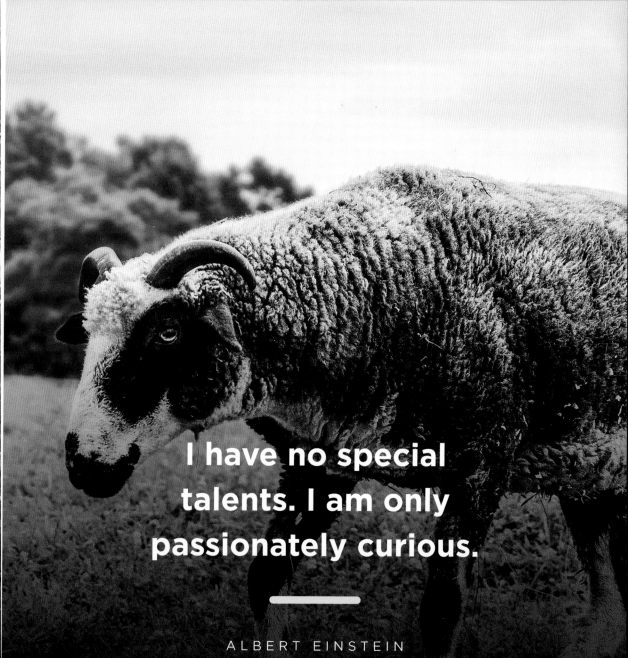

I have no special talents. I am only passionately curious.

ALBERT EINSTEIN

Women who seek to be equal to men lack ambition.

―――

MARILYN MONROE

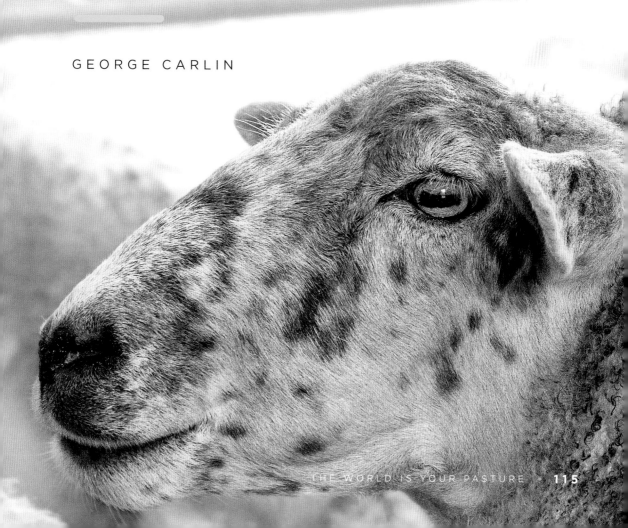

It's important in life if you don't give a shit. It can help you a lot.

GEORGE CARLIN

I asked God for a bike, but I know God doesn't work that way. So I stole a bike and asked for forgiveness.

———

EMO PHILIPS

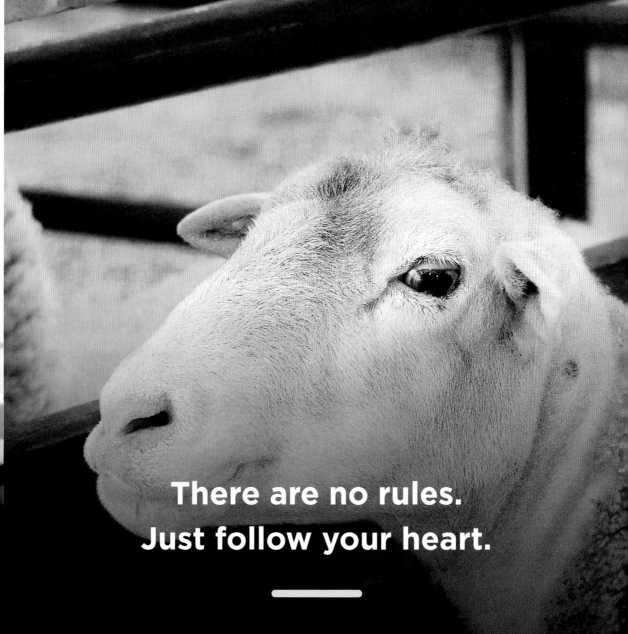

**There are no rules.
Just follow your heart.**

———

ROBIN WILLIAMS

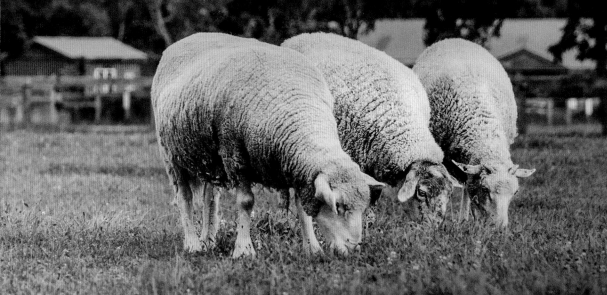

Nobody can discover the world for somebody else. Only when we discover it for ourselves does it become common ground and a common bond and we cease to be alone.

WENDELL BERRY

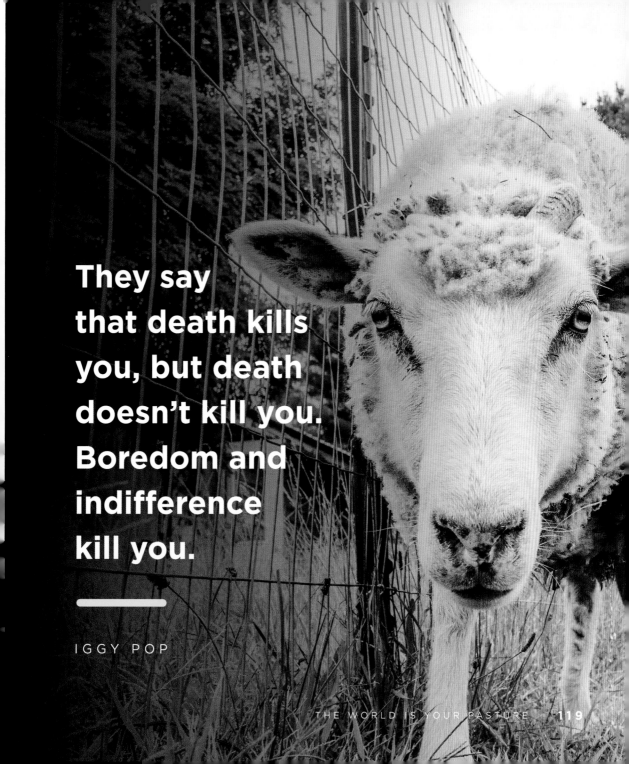

They say
that death kills
you, but death
doesn't kill you.
Boredom and
indifference
kill you.

IGGY POP

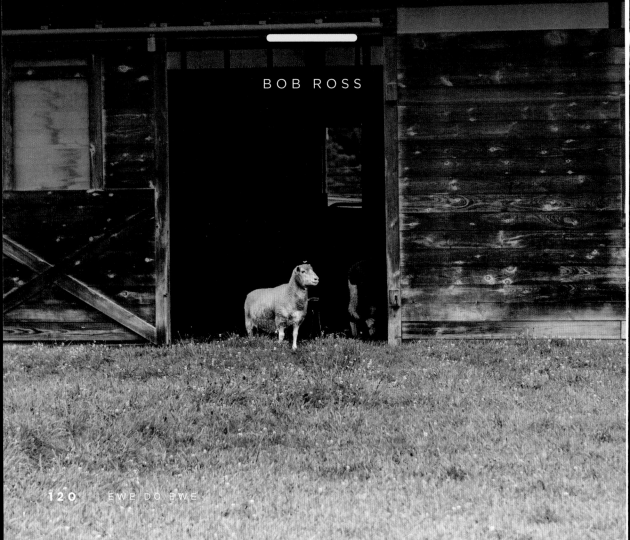

Talent is a pursued interest. Anything that you're willing to practice, you can do.

BOB ROSS

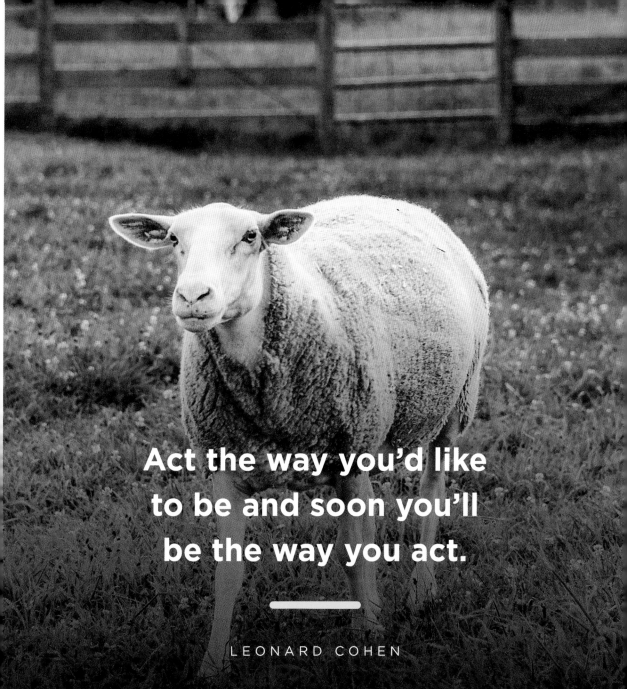

Act the way you'd like
to be and soon you'll
be the way you act.

———

LEONARD COHEN

Choose a goal that seems right for you and strive to be the best, however hard the path. Aim high. Behave honorably. Prepare to be alone at times, and to endure failure. Persist! The world needs all you can give.

E. O. WILSON

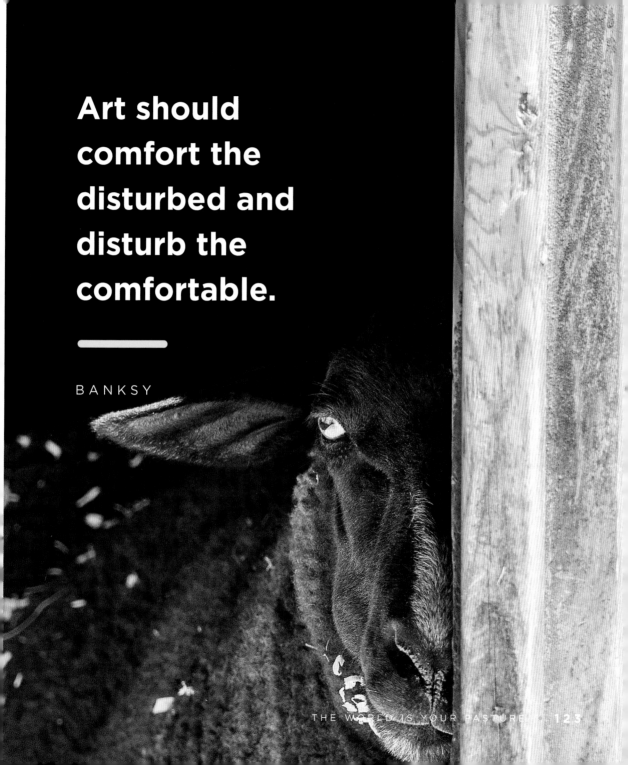

Art should comfort the disturbed and disturb the comfortable.

BANKSY

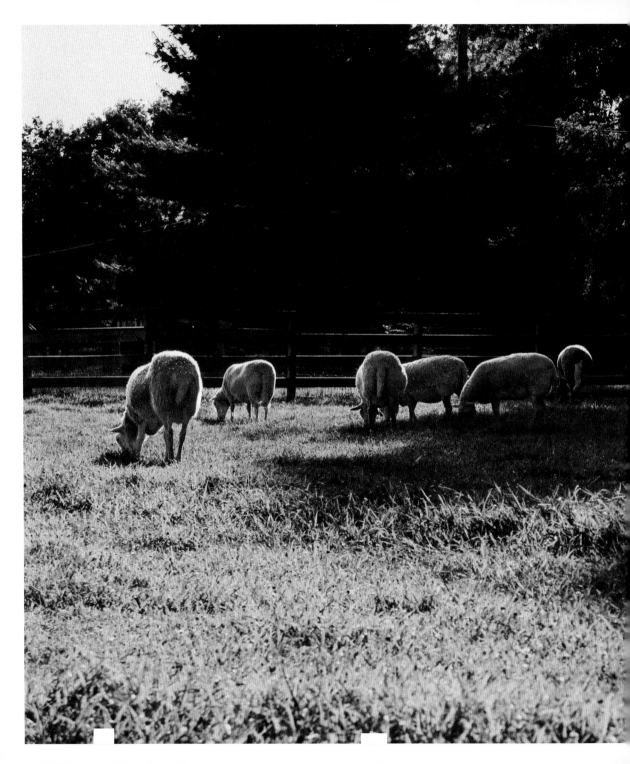

Find something you're passionate about and keep tremendously interested in it.

JULIA CHILD

Achievement is talent plus preparation.

———

MALCOLM GLADWELL

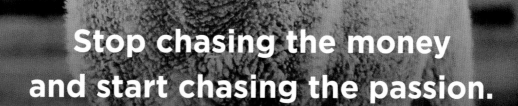

Stop chasing the money and start chasing the passion.

———

TONY HSIEH

I am little concerned with beauty or perfection. I don't care for the great centuries. All I care about is life, struggle, intensity.

———

EMILE ZOLA

Make bold choices and make mistakes. It's all those things that add up to the person you become.

ANGELINA JOLIE

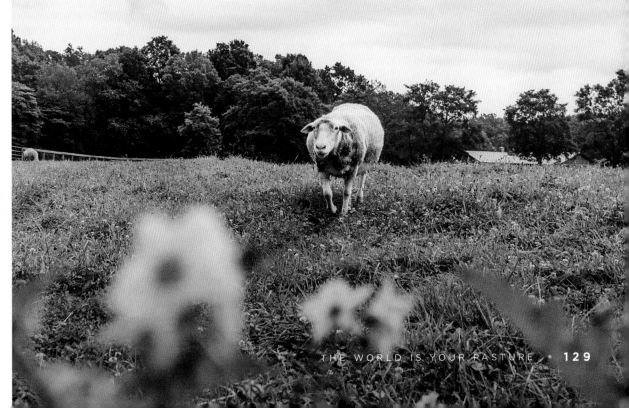

5

FUZZY FEELINGS

Who, being loved, is poor?

————

OSCAR WILDE

There's no bad consequence to loving fully, with all your heart. You always gain by giving love.

———

REESE WITHERSPOON

What we have once enjoyed we can never lose. All that we love deeply becomes a part of us.

HELEN KELLER

Love recognizes no barriers.
It jumps hurdles, leaps fences,
penetrates walls to arrive at
its destination full of hope.

MAYA ANGELOU

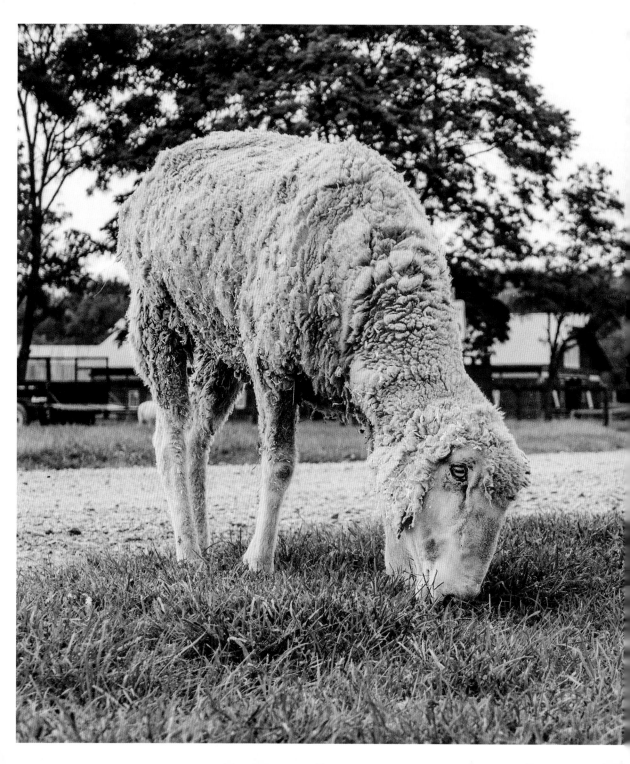

There is nothing more truly artistic than to love people.

VINCENT VAN GOGH

Animals are such agreeable friends—they ask no questions; they pass no criticisms.

GEORGE ELIOT

I love being married.
It's so great to find
that one special person
you want to annoy for
the rest of your life.

RITA RUDNER

Never close your lips to those [to] whom you have already opened your heart.

CHARLES DICKENS

True love comes quietly, without banners or flashing lights. If you hear bells, get your ears checked.

———

ERICH SEGAL

All you need is love.
But a little chocolate now
and then doesn't hurt.

CHARLES SCHULZ

I don't want to live, I want to love first and live incidentally.

ZELDA FITZGERALD

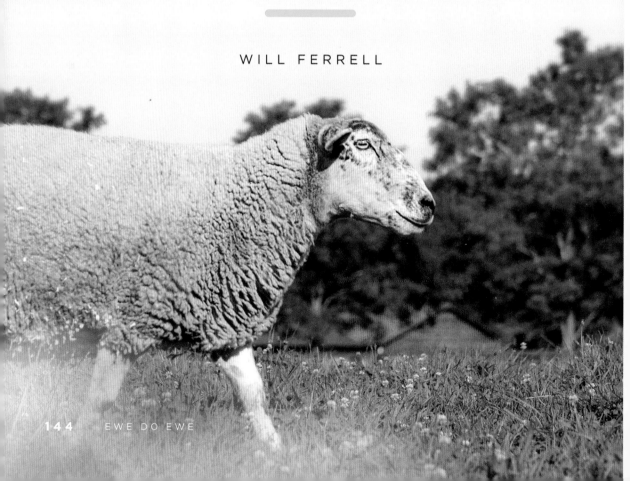

Before you marry a person, you should first make them use a computer with slow internet to see who they really are.

WILL FERRELL

Romantic love is a mental illness. But it's a pleasurable one.

FRAN LEBOWITZ

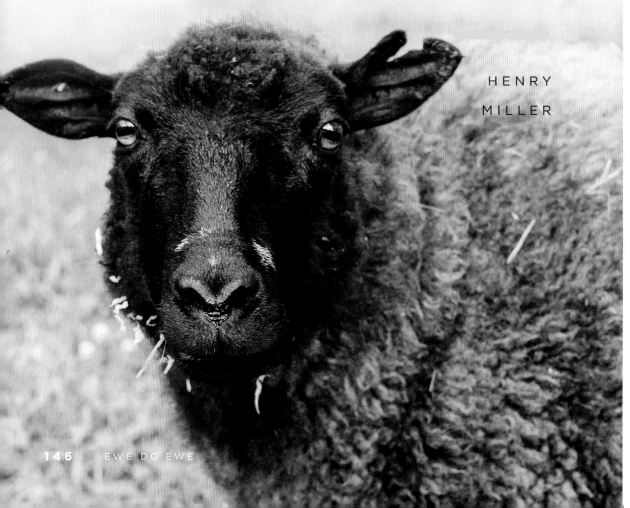

The only thing we never get enough of is love; and the only thing we never give enough of is love.

HENRY MILLER

Sorrow is how we learn to love. Your heart isn't breaking. It hurts because it's getting larger. The larger it gets, the more love it holds.

———

RITA MAE BROWN

Love is a fire, but whether it is going to warm your hearth or burn down your house, you can never tell.

—

JOAN CRAWFORD

Nothing I accept about myself can be used against me to diminish me.

———

AUDRE LORDE

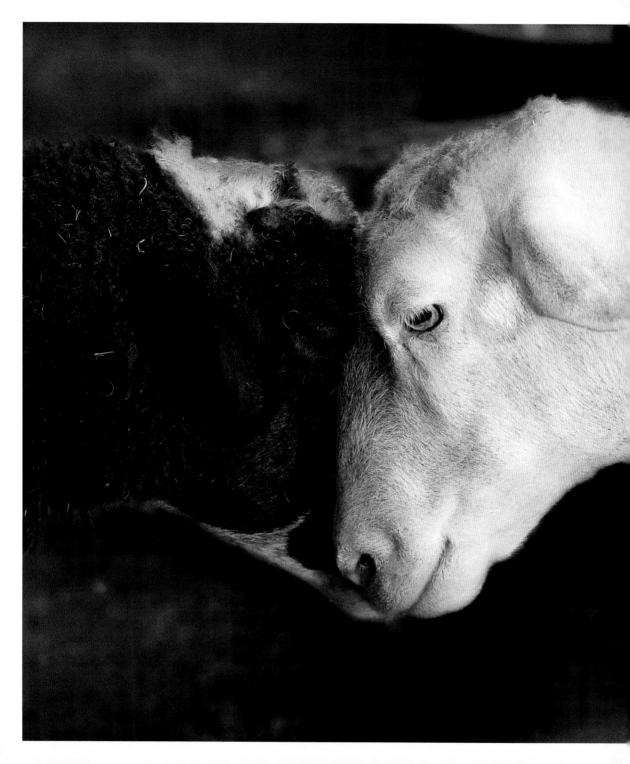

We are most alive when we're in love.

JOHN UPDIKE

6

OFFERING A SHEEP TO LEAN ON

Thousands of candles can be lit by a single candle and the life of the candle will not be shortened. Happiness never decreases by being shared.

—

BUDDHA

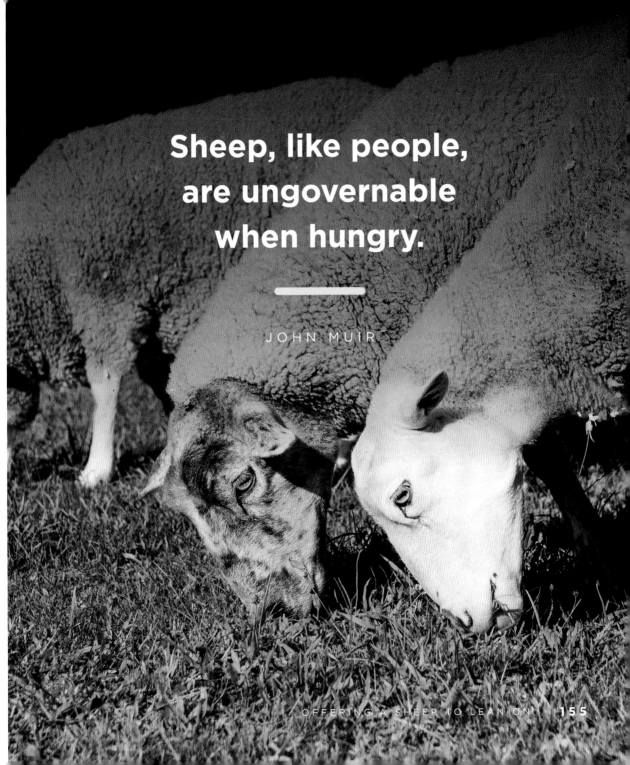

Sheep, like people,
are ungovernable
when hungry.

JOHN MUIR

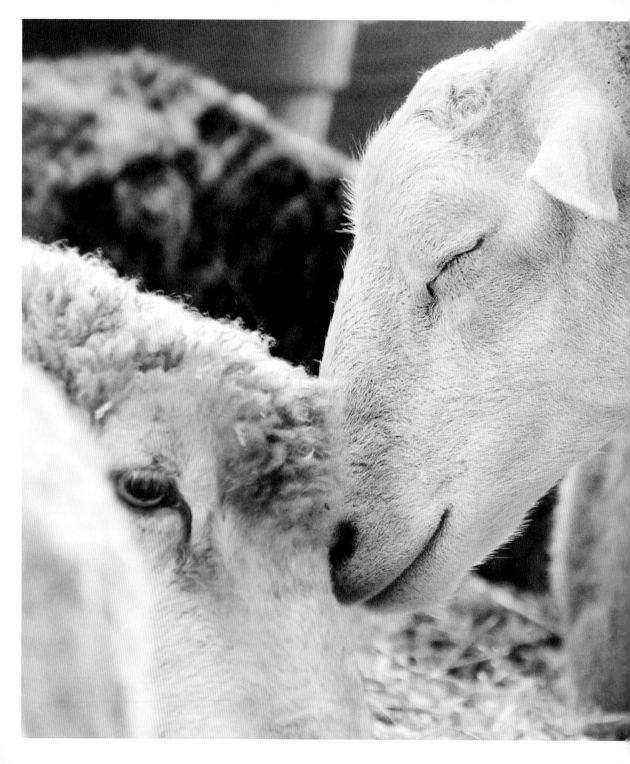

If more of us valued
food and cheer and
song above hoarded
gold, it would be
a merrier world.

J. R. R. TOLKIEN

Where there is shouting, there is no true knowledge.

LEONARDO DA VINCI

If we are to make reality endurable, we must all nourish a fantasy or two.

MARCEL PROUST

Spoon feeding in the long run teaches us nothing but the shape of the spoon.

E. M. FORSTER

I don't look
ahead. I'm right
here with you.
It's a good
way to be.

———

DANNY DEVITO

If you can learn to love yourself and all the flaws, you can love other people so much better.

KRISTIN CHENOWETH

There is only
one happiness in
this life, to love
and be loved.

———

GEORGE SAND

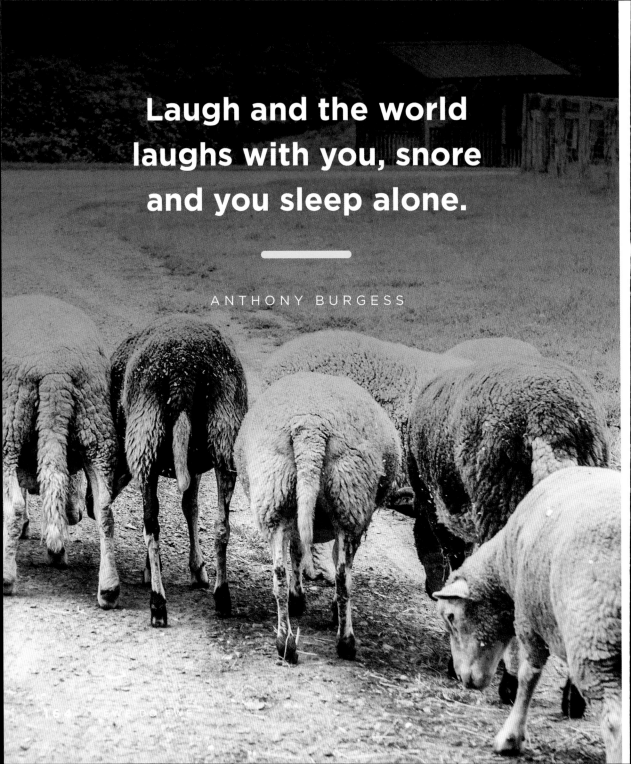

Laugh and the world laughs with you, snore and you sleep alone.

ANTHONY BURGESS

Friends are people who know you really well and like you anyway.

———

GREG TAMBLYN

Focusing your life solely on making a buck shows a certain poverty of ambition. It asks too little of yourself. Because it's only when you hitch your wagon to something larger than yourself that you realize your true potential.

———

BARACK OBAMA

I don't believe that if you do good, good things will happen. Everything is completely accidental and random. Sometimes bad things happen to very good people and sometimes good things happen to bad people. But at least if you try to do good things, then you're spending your time doing something worthwhile.

———

HELEN MIRREN

I think people who have faults
are a lot more interesting
than people who are perfect.

SPIKE LEE

I don't believe that there are aliens. I believe there are really different people.

———

ORSON SCOTT CARD

Why do we say "Have a great weekend?" That's just a spell. You're just going: I have no control over your weekend, but words matter. They change our interior world. Have a great weekend.

PETE HOLMES

A true friend is someone who thinks that you are a good egg even though he knows that you are slightly cracked.

BERNARD MELTZER

Each of us has something
that no one else has—
or ever will have—
something inside that
is unique to all time.
It's our job to encourage
each other to discover
that uniqueness
and to provide
ways of developing
its expression.

FRED ROGERS

• EWE DO EWE

I have learned that
to be with those I
like is enough.

———

WALT WHITMAN

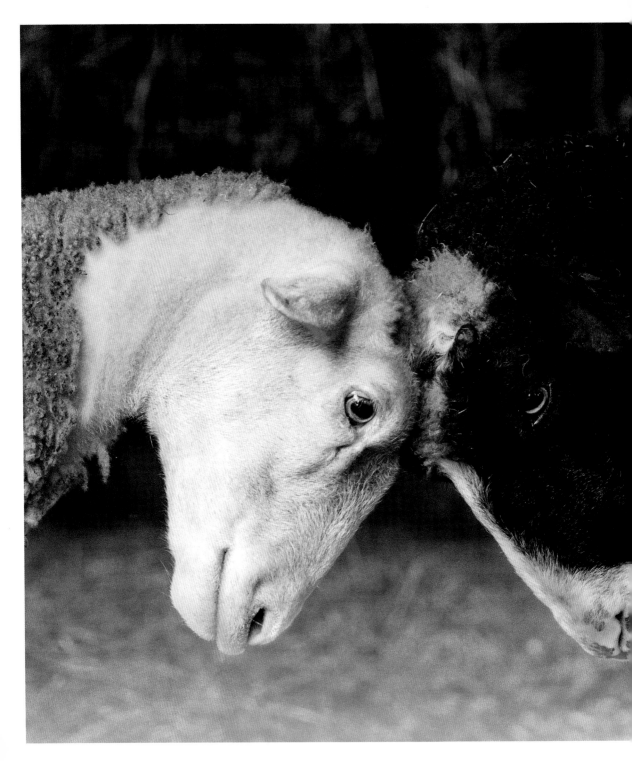

I would rather walk with a friend in the dark, rather than alone in the light.

HELEN KELLER

7

TAKING TIME TO RE-LAMB

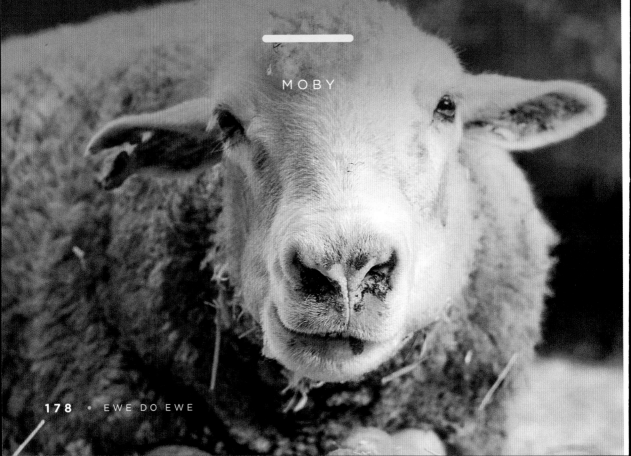

Whenever I've had success, I never learn from it. Success usually breeds a degree of hubris. When you fail, that's when you learn.

MOBY

Weekends don't count
unless you spend them doing
something completely pointless.

———

BILL WATTERSON

The future is called "perhaps," which is the only possible thing to call the future. And the important thing is not to allow that to scare you.

———

TENNESSEE WILLIAMS

Happiness is good health and a bad memory.

INGRID BERGMAN

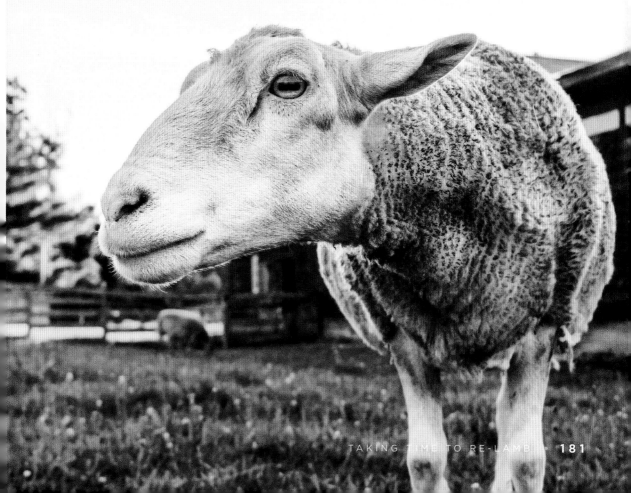

Time you enjoy wasting is not wasted time.

MARTHE TROLY-CURTIN

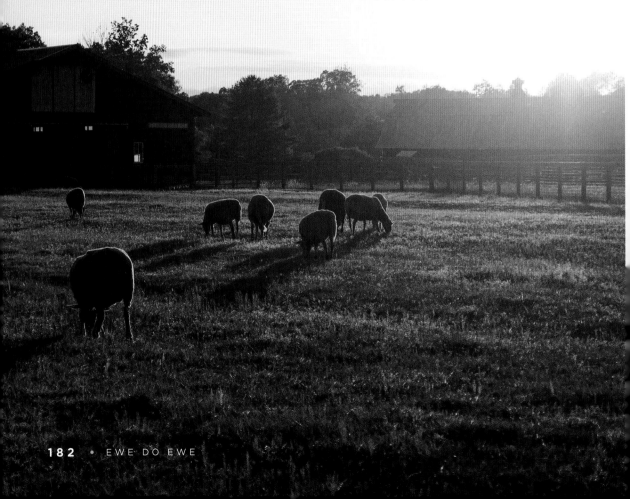

Serenity is knowing that your worst shot is still pretty good.

JOHNNY MILLER

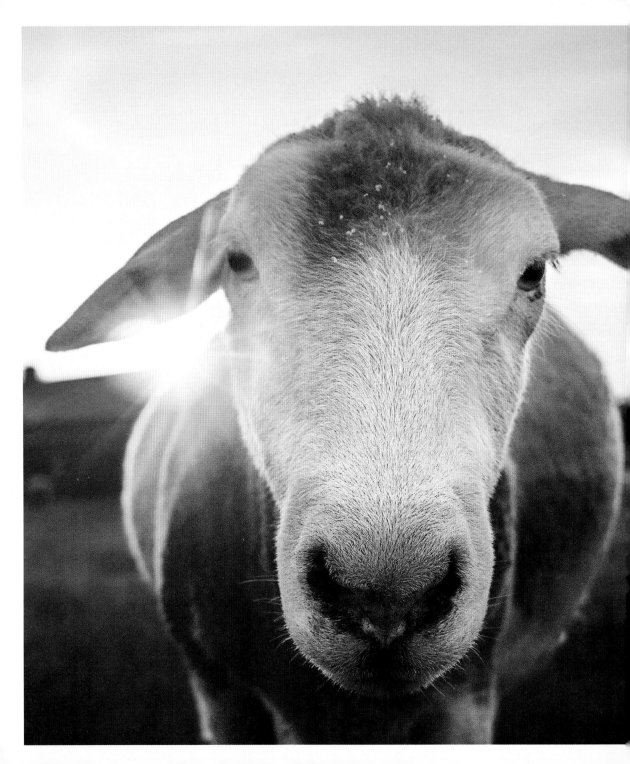

Don't watch the clock; do what it does. Keep going.

SAM LEVENSON

I've made peace with the fact that the things that I thought were weaknesses or flaws were just me. I like them.

———

SANDRA BULLOCK

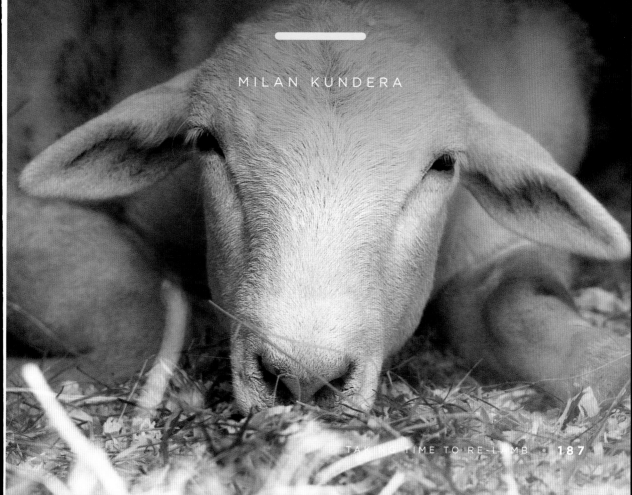

To sit with a dog on a hillside on a glorious afternoon is to be back in Eden, where doing nothing was not boring—it was peace.

MILAN KUNDERA

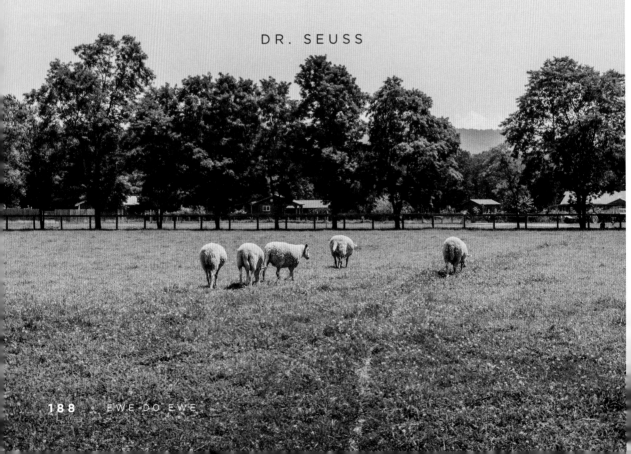

You have brains in your head. You have feet in your shoes. You can steer yourself any direction you choose.

DR. SEUSS

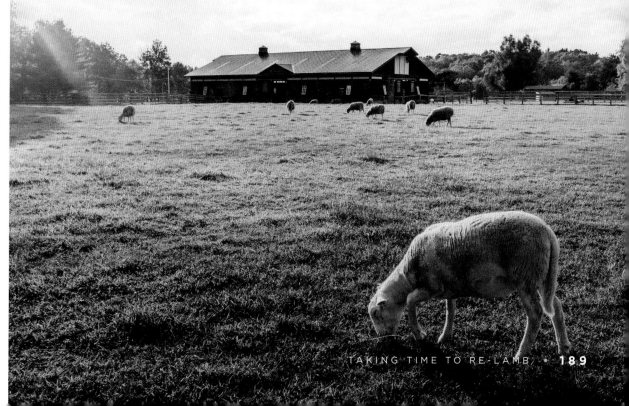

I may not have gone where I intended to go, but I think I have ended up where I needed to be.

DOUGLAS ADAMS

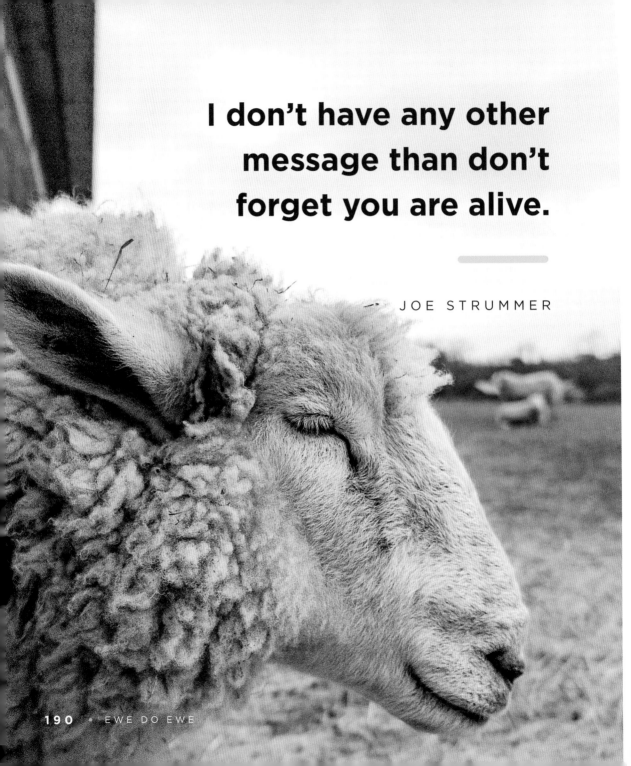

I don't have any other message than don't forget you are alive.

JOE STRUMMER

Beware the barrenness of a busy life.

SOCRATES

Learn what is to be
taken seriously and
laugh at the rest.

HERMAN HESSE

A failure is not always a mistake, it may simply be the best one can do under the circumstances. The real mistake is to stop trying.

B. F. SKINNER

I'm sick of following my dreams, man. I'm just going to ask where they're going and hook up with 'em later.

— MITCH HEDBERG

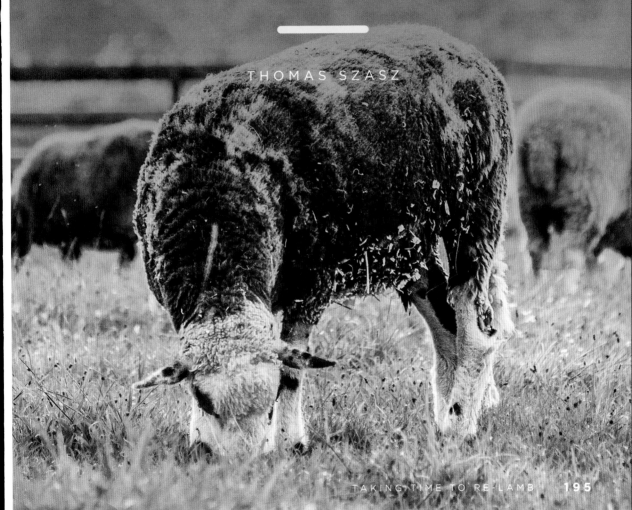

Boredom is the feeling that everything is a waste of time; serenity, that nothing is.

THOMAS SZASZ

Ah! There is nothing like staying at home, for real comfort.

——

JANE AUSTEN

If you don't think every day is a good day, just try missing one.

CAVETT ROBERT

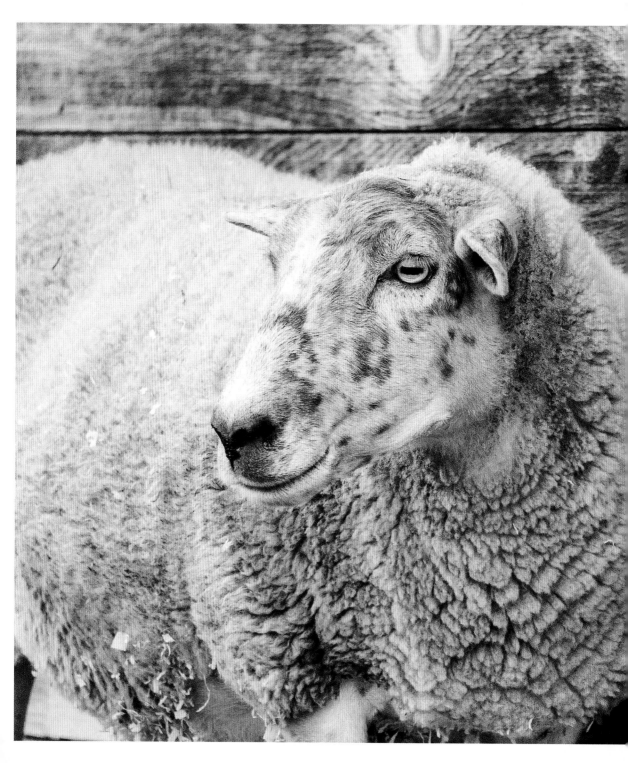

The main thing to do is relax and let your talent do the work.

CHARLES BARKLEY

My therapist told me the way to achieve true inner peace is to finish what I start. So far I've finished two bags of M&Ms and a chocolate cake. I feel better already."

———

DAVE BARRY

Rest is not idleness, and to lie sometimes on the grass under trees on a summer's day, listening to the murmur of the water, or watching the clouds float across the sky, is by no means a waste of time.

JOHN LUBBOCK

When all else fails there's always delusion.

—

CONAN O'BRIEN

Besides the noble art of getting things done, there is the noble art of leaving things undone. The wisdom of life consists in the elimination of nonessentials.

———

LIN YUTANG

8

ON
BAA-RAVERY

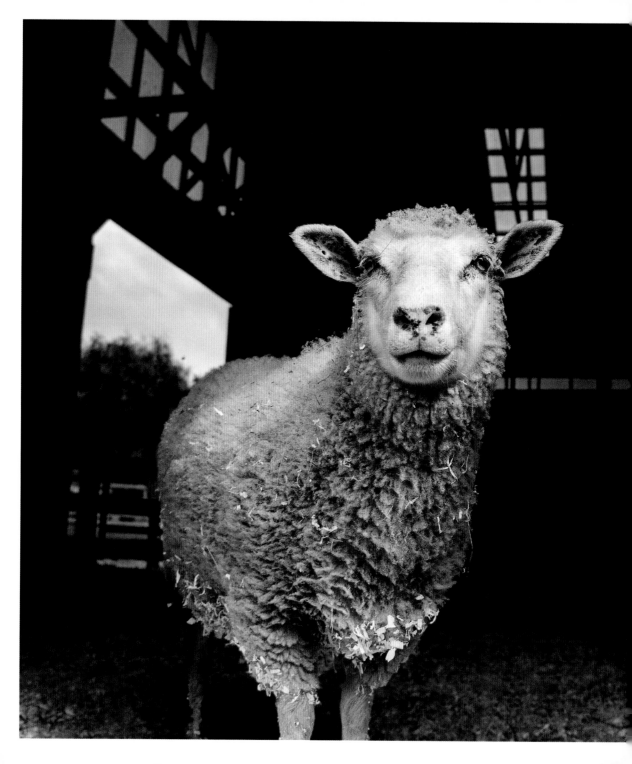

Some people say, "Never let them see you cry." I say, if you're so mad you could just cry, then cry. It terrifies everyone.

———

TINA FEY

If you don't like the road you're walking, start paving another one.

DOLLY PARTON

I hope that in this year to come, you make mistakes. Because if you are making mistakes, then you are making new things, trying new things, learning, living, pushing yourself, changing yourself, changing your world. You're doing things you've never done before, and more importantly, you're doing something.

NEIL GAIMAN

I was built this way for a reason, so I'm going to use it.

—

SIMONE BILES

Do not judge me by my successes, judge me by how many times I fell down and got back up again.

———

NELSON MANDELA

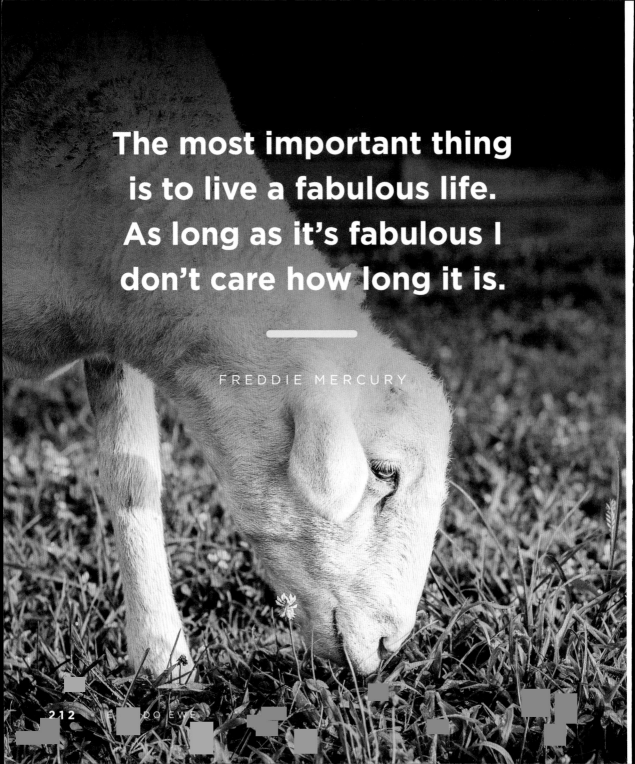

The most important thing is to live a fabulous life. As long as it's fabulous I don't care how long it is.

FREDDIE MERCURY

I have learned over the years that when one's mind is made up, this diminishes fear; knowing what must be done does away with fear.

ROSA PARKS

In the face of such hopelessness as our eventual, unavoidable death, there is little sense in not at least trying to accomplish all of your wildest dreams in life.

KEVIN SMITH

Accumulating injuries are the price we pay for the thrill of not having sat around on our asses.

———

MARK RIPPETOE

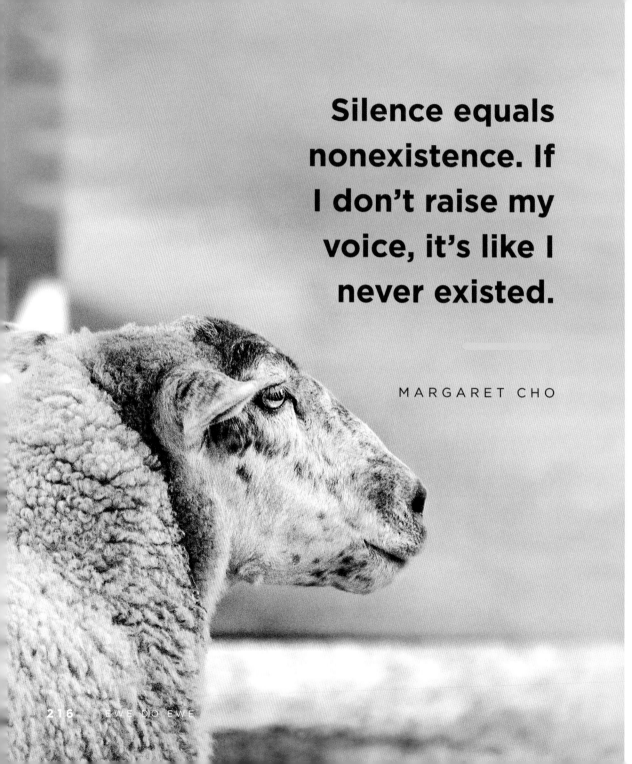

Silence equals nonexistence. If I don't raise my voice, it's like I never existed.

MARGARET CHO

People will kill you over time, and how they'll kill you is with tiny, harmless phrases, like "be realistic."

DYLAN MORAN

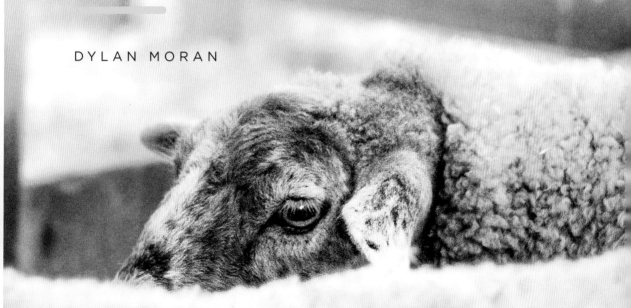

Saying "yes" is how things grow. Saying "yes" leads to knowledge. "Yes" is for young people. So for as long as you have the strength to, say "yes."

STEPHEN COLBERT

Courage is being afraid but going on anyhow.

DAN RATHER

If you even dream of beating me you'd better wake up and apologize.

———

MUHAMMAD ALI

Sometimes you just have to put on lip gloss and pretend to be psyched.

MINDY KALING

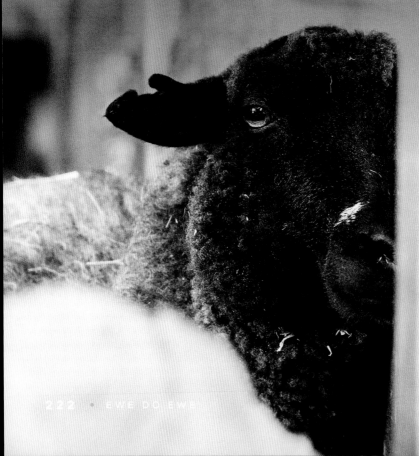

Decide whether or not the goal is worth the risks involved. If it is, stop worrying.

AMELIA EARHART

Be fanatically
positive and
militantly optimistic.
If something is
not to your liking,
change your liking.

RICK

STEVES

If you want to improve, be content to be thought foolish and stupid.

EPICTETUS

The difference between perseverance and obstinacy is that one comes from a strong will; and the other from a strong won't.

———

HENRY WARD BEECHER

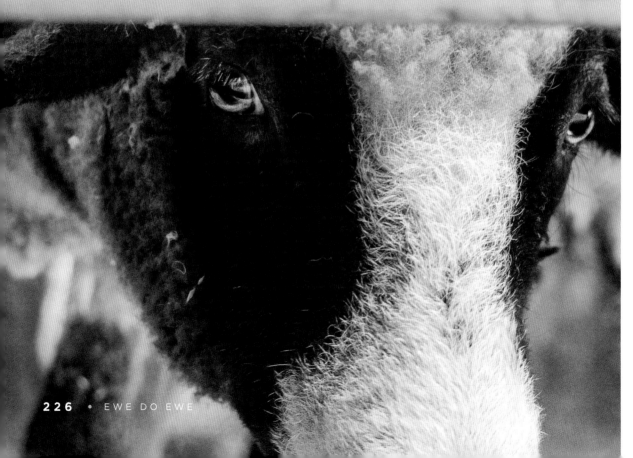

We learn wisdom from failure much more than success.

SAMUEL SMILES

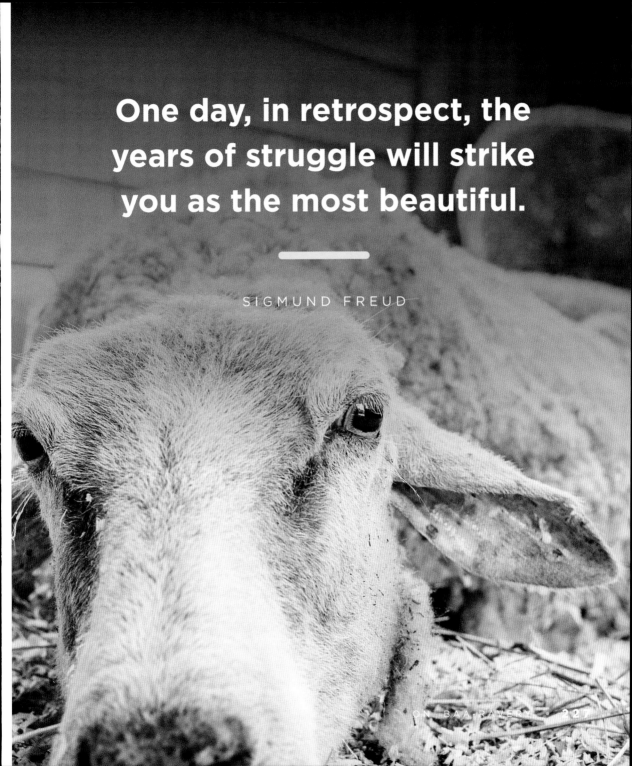

One day, in retrospect, the years of struggle will strike you as the most beautiful.

SIGMUND FREUD

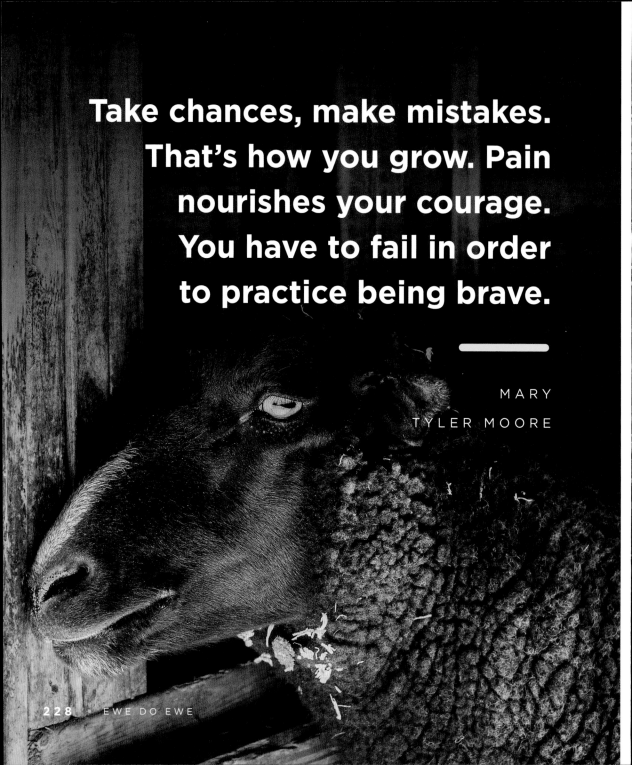

Take chances, make mistakes. That's how you grow. Pain nourishes your courage. You have to fail in order to practice being brave.

MARY TYLER MOORE

If you care about what you do and work hard at it, there isn't anything you can't do if you want to.

———

JIM HENSON

Everyone wants to live on top of the mountain, but all the happiness and growth occurs while you're climbing it.

———

ANDY ROONEY

I have great faith in fools—self-confidence my friends will call it.

———

EDGAR
ALLAN POE

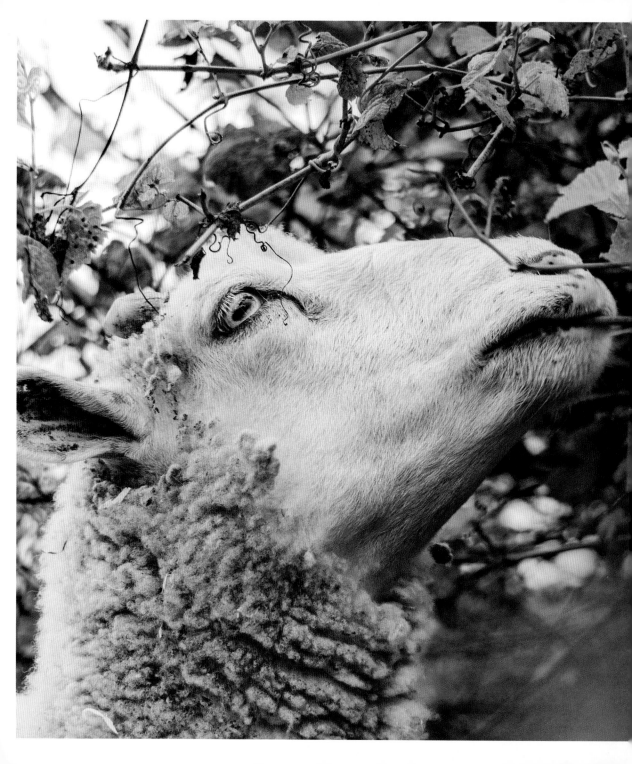

In order to achieve anything you must be brave enough to fail.

―――――

KIRK DOUGLASS

Everybody has talent, it's just a matter of moving around until you've discovered what it is.

———

GEORGE LUCAS

When I hear people boo, that just makes me want to go out there and work harder.

JOHN CENA

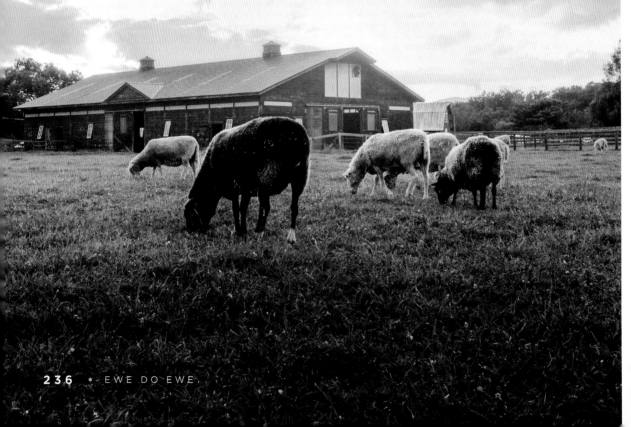

Don't be afraid to be confused. Try to remain permanently confused. Anything is possible.

GEORGE SAUNDERS

Put a grain of boldness into everything you do.

BALTASAR GRACIÁN

About the Photographer

Bridget Curtin is a photographer from Philadelphia whose work showcases nature and the vibrant lives of happy animals. Bridget hopes that her work will inspire people to support sanctuaries that save and provide long lives to animals. To see more of Bridget's work and to learn more about how you can support sanctuaries, visit www.bridgetmaeve.com and follow Bridget on Instagram @bridgetmaevephoto.